THE PINAKOTHEK MUSEUMS
IN BAVARIA

TREASURES AND LOCATIONS
OF THE BAVARIAN STATE PAINTING COLLECTIONS

The Pinakothek Museums in Bavaria

Edited by Bernhard Maaz

HIRMER

Contents

The Pinakothek Museums in Bavaria

The Bayerische Staatsgemäldesammlungen (Bavarian State Painting Collections) enjoy the reputation of housing the world's largest self-contained treasury of pictures. And even if superlatives are no more called for than comparisons with the Louvre or the Hermitage, nonetheless such a – particularly pleasing – rumour gives some idea of the richness of the collections. Over the course of five centuries the volume of works has grown both in Munich and in the branch collections (otherwise known as the State Galleries) thanks to the collecting activities first by princes, then kings, later the state and finally private individuals to reach what is now a total of more than 25,000 works of art. It is worth noting in passing that there is no need to display everything all the time. Many items have to be temporarily retrieved from the treasure house of the repository for special exhibitions, while others are on provisional or permanent loan to museums throughout the state of Bavaria. What matters is the richness of the collections on permanent display in some twenty locations briefly described in this book. There is not yet a general awareness that alongside the collections in Munich itself, which include not only the Alte Pinakothek, Neue Pinakothek, Pinakothek der Moderne, but the Schack Collection and Museum Brandhorst as well, there are also a number of State Galleries – from Augsburg and Aschaffenburg via Bamberg and Bayreuth all the way to Würzburg – with countless paintings from the Munich collection. In some cases they have been there for centuries.

The origins of this history of collecting go back to 1528, when Duke William IV commissioned a cycle of history paintings, much of which is still preserved in Munich – pictures by artists in the circle of Albrecht Altdorfer which were visually so striking that they continue to fascinate to this day. Consider, for example, the famous visionary 'Battle of Issus (Alexander's Battle)' (fig. p. 16). Here, art was already exercising not only its legitimatory function, but also its entertainment value, its value as a 'spectacle'. Back in 1563 work began in Munich on establishing a 'Kunstkammer'. For the Bavarian court, as for many others in Europe, such a cabinet of curiosities was significant in creating a place dedicated to collecting, since it was not until later that the picture gallery was established as an architectural form.

7

In Munich's case, the Hofgartengalerie to the north of the ducal palace, the Residenz, was completed around 1780 as an early example of a gallery built in its own right. The collections in Munich grew not only as a result of systematic purchases on the international art market, which as early as the late seventeenth century included extensive acquisitions of Flemish painting – such as a dozen pictures by Peter Paul Rubens. They also grew through inheritance when the collections from Mannheim, Zweibrücken and Düsseldorf, so rich in tradition, were assembled in Munich upon the junior branch of the main line of the Wittelsbach dynasty becoming extinct in 1777. An additional factor was the dissolution of numerous monasteries and collegiate churches from 1802/03 onwards that also led to enlargements of the collections. This meant the Centralgemäldegaleriedirektion (Central Directorate of Picture Galleries), set up in 1799, soon had an immense stock at its disposal. It resulted in the founding of branch galleries in Ansbach, Augsburg, Aschaffenburg, Bamberg, Nuremberg and Würzburg as a logical solution to distributing the works. This rational system of intelligent dispersal of such rich and important collections has stood the test of time and forms the basis for the structure of our book, one which seeks to provide an overview and ultimately to inspire, encourage and entice readers to visit these places.

As far back as feudal times the paintings on display in palaces like Schleissheim were regarded as state treasures, as testimonies to culture and a stimulating basis for conversation. Looking at a portrait, one could talk about the person portrayed; a battle scene could prompt a discourse on military strategy. History painting offered exemplars of virtuous behaviour, while Christian motifs could be linked to the social norms of the time. As for still life, that might suggest a discussion on the transience of earthly things or the rarity, costliness and exotic nature of the objects depicted. Even though they may have been explained by gallery attendants or indeed directors, artworks were there not just to demonstrate wealth, cause amazement and encourage intellectual exchange. Even in the cabinet of curiosities they were part of a visual model for explaining the world – a function they have retained to this day.

Nevertheless it seems easier to understand the messages of works created in the two centuries between the young Goethe and late Thomas Mann, between the Enlightenment that was dawning and the early twentieth century. After all, the themes – landscape painting or portraiture, for instance – are often more in tune with today's range of experience. Moreover, the pictures painted by artists of the 'Blauer Reiter' or the 'Brücke' movements, for example, are more familiar to the modern visitor. The situation is different yet again when it comes to the works in the Pinakothek der Moderne and (at times) the

Glaspalast in Augsburg. While artists around 1800 were losing their courtly and ecclesiastical clientele, and selling on the open market instead, the focus in the twentieth century was on oppositional tendencies and social critique. This can be witnessed in the Bavarian State Painting Collections by visiting the Pinakothek der Moderne, where the frequent change of presentations goes hand in hand with the ongoing rewriting of the canon of modern art. On display here are works ranging from the analytical realism of Otto Dix all the way through to the individually encrypted questioning of society by Joseph Beuys. Museums have always been, and will continue to be, places of experimentation, of experience, of discovery.

In order to appreciate the immense riches of the Bavarian State Painting Collections, one should visit not just the museums in Munich, but also the branch galleries scattered throughout Bavaria. We are still a long way from digitizing the entire stock; and even if all the pictures were digitally accessible, there is still no substitute for the immediate impression the viewer gains from standing in front of the original. The artworks – unlike their digital reproductions on screen – are of different dimensions. Some are miniatures inviting closer inspection, while others are gigantic and require the viewer to keep a respectful distance. In addition, most have historic frames, some gilt and some with the wood showing through, some richly Baroque in their decoration, others classically plain. Another aspect that can be seen only in the original is the texture, sometimes coarse, sometimes fine, of the canvas or the grain of the wood. All the pictures have a body consisting of picture support and frame, paint and varnish. The interaction of space and picture, of groups of pictures with principal and subsidiary works, can only be experienced in a museum. This is what gives museums their *raison d'être*, and why they can be confident about their future. They will never become redundant but will remain places of encounter with the original.

Why are the State Galleries so important for all of Bavaria? It is a fine tradition to provide through them a short and easy access to art throughout the state. By providing the funds to keep these institutions going, Bavaria has since time immemorial possessed this great gift: the opportunity to see artworks at the highest level and in the original. This way, towns and cities are able to carry out educational work in the museums and provide attractions for tourists on site. In addition, hundreds of artworks from the Bavarian State Painting Collections are on permanent loan to a variety of institutions, many of them museums (pp. 171–73) – among them some 223 works at the Germanisches Nationalmuseum in Nuremberg alone. This, too, is a fundamental form of ongoing democratic participation.

In each of the State Galleries there are, as the Augsburg example shows, sometimes mixed presentations of works in local rather than Munich possession. This provides an additional perspective through reciprocal elucidation and enrichment to lend further dimensions of meaning to the art available locally. And it serves as a reminder that art belongs in a higher, ideal sense to humanity and, in the very best sense, to us all. That does not relieve museums of their duty of care and conservation; indeed it makes it clear that often artworks cannot for reasons of restoration travel to exhibitions. But it also shows that our permanent exhibitions are the real treasure deserving our closest attention. To revisit a familiar artwork from time to time means experiencing how it continues to say something to us anew (or indeed something new). And it also shows how we ourselves as beholders change, opening up to the unknown or the previously unrecognized. It is about nothing less than deeper, enhanced insights through repeated viewing, for just as we hear the same pieces of music over and over again, we need to see, experience and understand artworks by returning to them in order to discover deeper layers. For today's public, accustomed to an ever-changing flood of up-to-the-minute images that are rapidly taken in (and sometimes too quickly ticked off as 'seen' and so cast off as yesterday's news), this fundamental aspect is often insufficiently present. However, in the case of museums this kind of repeated encounters, with deeper insights each time, is decisive.

This book, to which numerous curators at the Bavarian State Painting Collections have contributed, is intended to tempt our readers to open up to these enduring and impressive riches, to indulge in the variety of the State Galleries and experience the different architectures documented in Martin Fengel's pictures – yet recorded with artistic freedom and an individual vantage point. The cosmos of galleries also includes, incidentally, the Olaf Gulbransson Museum at Lake Tegernsee, an architectural jewel by Sep Ruf and a treasure house of humour (pp. 161–63).

Behind the scenes at all these venues and activities there are not just competent art historians, but also the Munich-based Central Administration of the State's Collections and Museums, the Doerner Institut with its long tradition, and also numerous experts and conservators to guarantee the best possible preservation of all these treasures. Even when in the future the developments in digital strategies enable us to see many an artwork on the Internet, it will still remain the overriding duty of the museum to look after and present the originals in the best way possible. In the case of the branch galleries, the Bavarian Palace Department is, as a rule, the ideal partner. For, as readers of this book will find, the fact that the works in the Bavarian State Painting Collections

can be seen in such a good light – indeed can be seen at all – is due to the team-work of all those involved. As for visiting our galleries in large numbers and at frequent intervals, and deriving new pleasure from our treasures with each attendance – that responsibility, dear readers, lies entirely with you!

Bernhard Maaz
Director-General of the Bavarian State Painting Collections

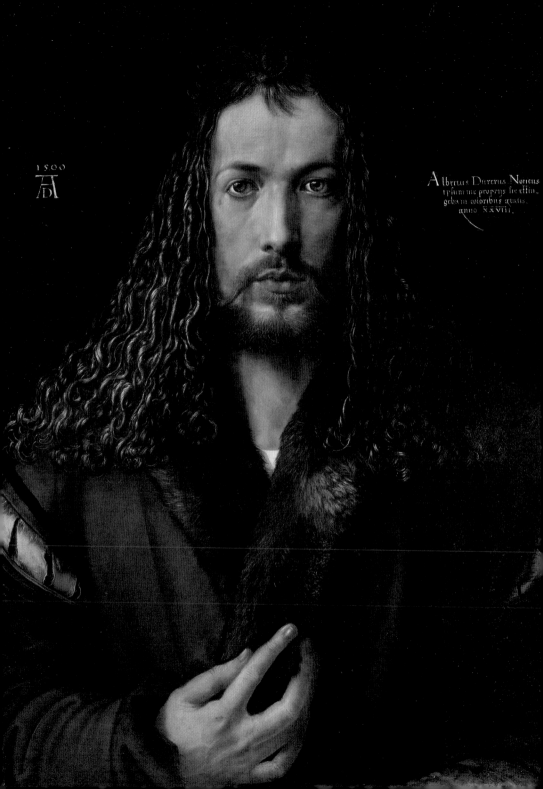

1500

Albertus Dürerus Noricus
ipsum me propriis sic effin=
gebam coloribus aetatis
anno XXVIII.

Munich
Alte Pinakothek

Barer Strasse 27, 80799 Munich, entrance Theresienstrasse | T +49 (0)89 23805 216 |
Open daily except Mondays | Disability-friendly access | www.pinakothek.de/alte-pinakothek

The Alte Pinakothek is a treasure house of painting, with row upon row of major European artworks hung next to another, many of which can claim world-class status. Van der Weyden, Memling, Dürer, Grünewald, Cranach, Raphael, Leonardo, Titian, Tintoretto, van Dyck, Rubens, Rembrandt, Poussin, Barocci, Reni, Claude Lorrain, El Greco, Velázquez, Murillo, Boucher and Tiepolo: they are just some of the artists whose works are included in the total of 700 paintings on display. Can one possibly do justice to such a prestigious collection on just twelve pages?

Visitors to the gallery are received by a row of earnest gentlemen: the founders of the collection, who resided not only in Munich and Schleissheim, but also in Düsseldorf, Mannheim and Karlsberg Castle between the sixteenth and eighteenth centuries. Over the generations these different branches of the Wittelsbach dynasty amassed a huge collection of several thousand Old Master paintings. In the period of the territorial reorganization of Bavaria around 1800, the dynastic succession brought the pictures to Munich. Several hundred more works were added as a result of the dissolution of the monasteries and collegiate churches that followed and, not least, thanks to the systematic acquisitions of the crown prince and future king, Ludwig I. By 1822, the inventory already listed more than 7,000 pictures: too many for one museum alone! So, starting in 1803, branch galleries were set up throughout the electorate and future kingdom of Bavaria, some of which also served as repositories. The best works were to be shown across the state, but the best of the best, it goes without saying, in the royal capital of Munich. The collection had long since outgrown the gallery established by Elector Karl Theodor above the Hofgarten arcade in Munich around 1780. A new building was needed, preferably outside the old city walls, where there was less risk of fire.

Between 1826 and 1836 the Maxvorstadt district witnessed the construction of the new gallery on a largely unbuilt-on area to the north-west of the old heart of the city. It was designed by the architect Leo von Klenze, with whom the imaginative and energetic King Ludwig I was creating a new Munich. The solitary building stood within sight of Klenze's earlier work, the Glyptothek. In contrast to the Königsplatz, the Renaissance style of Roman-Florentine

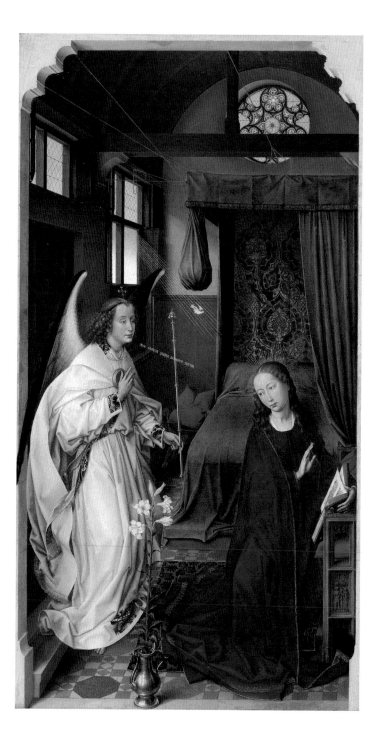

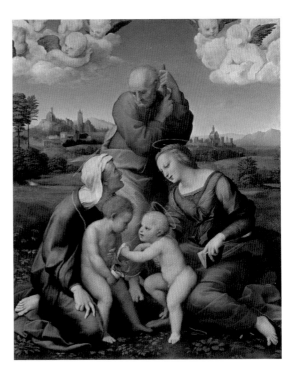

architecture was chosen as more appropriate for the gallery. With its division into large sky-lit halls and smaller cabinet rooms lit from the side, the building became the model for museum design for the rest of the century. King Ludwig gave the building a name, unique in the German-speaking area, derived from the Greek: Pinakothek. It was only when a second, 'new' Pinakothek was built ten years later that the older building became known as the 'Alte' (Old) Pinakothek.

Today, the original Alte Pinakothek is recognizable only by its external contours, internal structure and the sequence of halls and cabinet rooms. The Second World War left deep scars, and the stucco and gold have disappeared. Reconstruction was undertaken amid a mood of vulnerability and purism. Out of thrift came grand solutions – such as the staircase, with which the architect Hans Döllgast made history. Built on the south side of the building to replace the former first-floor loggia with its fresco decoration, it is one of the exemplary architectural achievements of the 1950s. Though there are a number of lifts one can use instead, visitors should not shrink back from climbing the 72 steps. Once at the top, they will see the sad remains of the former frescoes

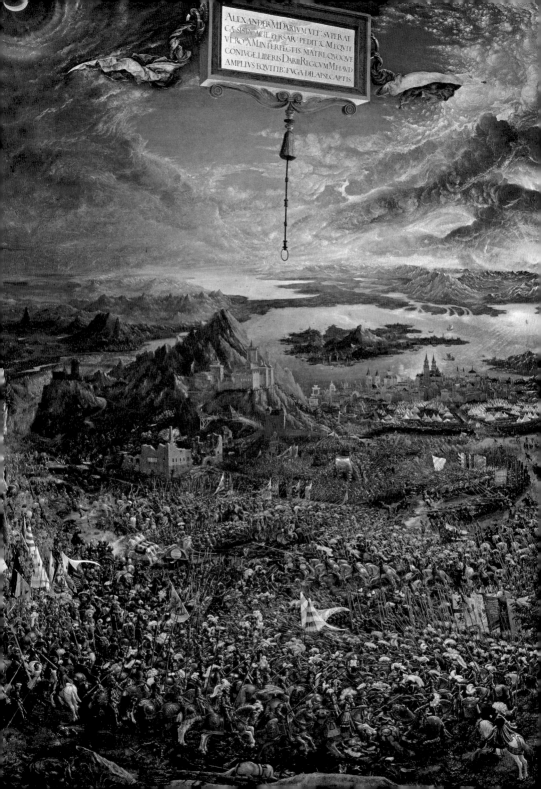

ALEXANDER·M·DARIVM·VLT·SVPERAT
CÆSIS·IN·ACIE·PERSAR·PEDIT·CM·EQVIT
VERO·X·M·INTERFECTIS·MATRE·QVOQVE
CONIVGE·LIBERIS·DARII·REG·CVM·M·HAVD
AMPLIVS·EQVITIB·FVGA·DILAPSI·CAPTIS

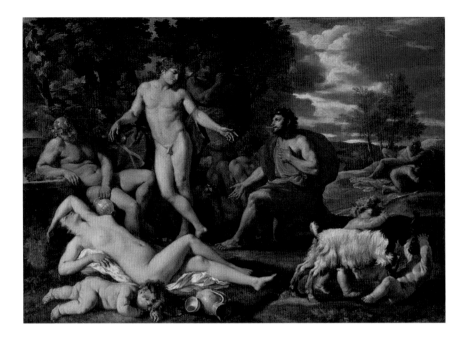

Albrecht Altdorfer, The Battle of Issus (Alexander's Battle), 1529 (detail) | Inv. No. 688
Nicolas Poussin, Midas and Bacchus, c. 1624 | Inv. No 528

before entering the gallery, whose walls were redecorated a few years ago in the traditional alternating colours of red and green.

Awaiting visitors here are 400 years of European painting, presented in chronological order and according to school. The silent solemnity of the pictures by Rogier van der Weyden and Hans Memling captivate the viewer, regardless of culture or educational background. One should take one's time to absorb the impact of the pictures, just as Goethe did on his visit to the Boisserée Collection in Heidelberg in 1815, where he spent a whole day before the Columba Altar. On the opposite wall are works from the Cologne School of painting, with their large expanses of gold ground. One also finds here numerous paintings from the Boisserée Collection, which was so large it could afford to share its wealth of Old Cologne paintings with the Germanisches National-museum in Nuremberg and the State Gallery in Bamberg.

The Dürer Room is devoted entirely to major works of European art: among them Albrecht Dürer's 'Self-Portrait' of 1500, his 'Four Apostles', Matthias Grünewald's panel of 'SS Erasmus and Maurice', the 'Crucifixion' by Lucas Cranach the Elder (a very early work and so most certainly executed entirely by him), Albrecht Altdorfer's 'Battle of Issus', which along with other history paintings of the period was already part of the earliest collection in

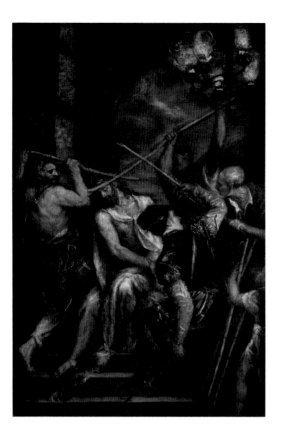

Titian, Christ Crowned with Thorns, c.1570 | Inv. No. 2272
Peter Paul Rubens, Rubens and Isabella Brant in the Honeysuckle Bower, c.1609/10 (detail) | Inv. No. 334

Munich. The change of epochs from Netherlandish painting and the Cologne School is palpable. Some of the figures are imposing by dint of their sheer size and radiate the self-confidence of their creators. Art was becoming political.

On display in the next two rooms are Italian paintings from the fifteenth and early sixteenth centuries. They include Filippo Lippi's 'Annunciation' with a foreshortened architectural backdrop that could have been designed by Brunelleschi; the sophisticated choreography of Sandro Botticelli's figures before Christ's tomb; Domenico Ghirlandaio's altarpiece from the high altar of Santa Maria Novella in Florence; and the marvellous composition of Raphael's 'Holy Family from the House of Canigiani'. The entire spectrum of Central Italian painting is represented. Here, too, in the Alte Pinakothek we will find the only painting of Leonardo to be seen in Germany.

Venetian painting of the sixteenth century has a dedicated room to itself. Even without knowledge of the biblical story, one would have to be heartless

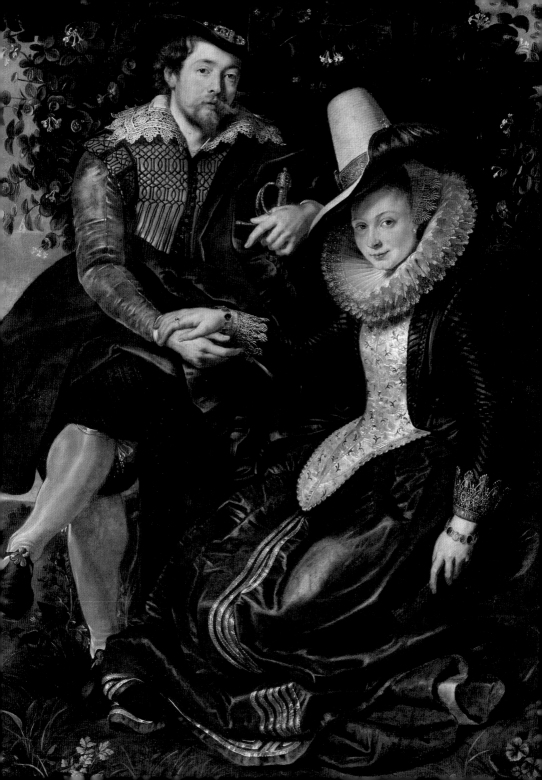

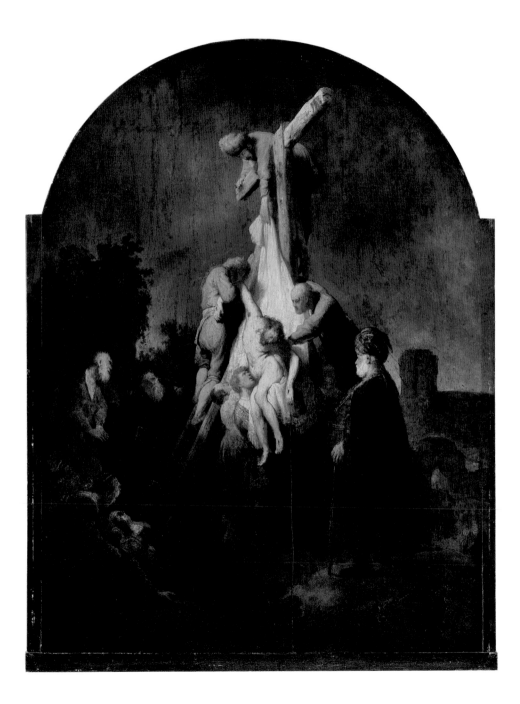

not to understand Titian's deeply moving 'Christ Crowned with Thorns'. Closer inspection of this three-metre picture reveals why the liberated style of the late Titian exercised such a fascination on succeeding generations of artists. Jacopo Tintoretto is represented with a number of paintings. His depiction of 'Christ in the House of Mary and Martha' comes from the Dominican church in Augsburg, a donation of the Welser family. The eight-part 'Gonzaga Cycle' from Mantua, high on the wall, is known to have been in Schleissheim as early as the eighteenth century.

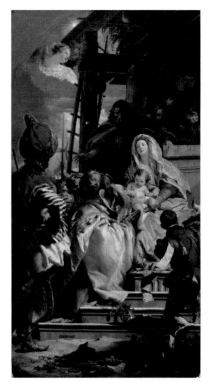

Flemish painting takes up most space in the Alte Pinakothek, with three rooms devoted to it. Outstanding works by Anthony van Dyck and Jacob Jordaens are well represented, but it is Peter Paul Rubens who dominates the middle of the building, keeping the heterogeneous wings of the gallery in balance. This is one of the largest collections of his works anywhere in the world. With his 'Last Judgement', more than six metres tall, the central hall is an artwork in itself. Visitors' progress through the museum will inevitably slow down as they linger to admire the family portraits – in particular the masterly double portrait of the newly-enamoured artist, just returned from Italy, with his wife, Isabella Brant, in the honeysuckle bower. Equally impressive are the dramatic hunting scenes and the numerous depictions with mythological and religious motifs. No task was ever too much for him, he once wrote. Rubens is simply overwhelming.

The mood changes abruptly in the hall containing the Dutch paintings. Unlike the Flemings, the Dutch had no interest in large altarpieces; their Calvinist churches were devoid of pictures. Dutch painting is with few exceptions confined to small and medium formats – ideally suited to hang in the homes of affluent merchants but not too small for princely collections either. In the seventeenth century, Dutch artists began to specialize in landscapes, still lifes, genre scenes and portraits – a trend which becomes palpable in this hall and the side-rooms.

There are ten Rembrandts on display. Some came from the Düsseldorf and Mannheim galleries and also Karlsberg Castle's Zweibrücken gallery: 'Abraham's Sacrifice of Isaac', 'The Holy Family', 'The Raising of the Cross' and 'The Deposition'. His 'Self-portrait at the Age of 23' is a later acquisition, as is the 'Portrait of Willem van Heythuysen' by Frans Hals, which only came to fill the gap among the full-length portraits in 1969.

The Italian Baroque in Room X is dominated by not one but two monumental paintings by Giovanni Battista Tiepolo. Here, it is his 1753 'Adoration of the Magi' from Münsterschwarzach Abbey that comes closest to the mature, routine dramaturgy of the Tiepolo we know from the Würzburg Residenz. The Caravaggesque naturalism of Carlo Saraceni, the empathy with the soul of a girl in love in Federigo Barocci's 'Noli me tangere', the cool classicism in Guido Reni's 'Assumption of the Virgin' – forms of artistic expression that could not be more different – are to be found here at the highest level.

French seventeenth-century painting is richly represented in the Alte Pinakothek with several works by Nicolas Poussin and Claude Lorrain. And although the Spanish section is, by number of works, the smallest group in the Bavarian State Painting Collections, it nevertheless contains works by all the great masters. Bartolomé Estéban Murillo's pictures of children are sophisticated presentations of a carefree world. The Alte Pinakothek possesses more works by this Andalusian painter than does almost any other collection. They come from the older Wittelsbach galleries. El Greco's 'Disrobing of Christ' as an expressionist precursor of incipient Modernism was not acquired until 1909.

Only in the last 40 years has it been possible to present French painting of the eighteenth century adequately, thanks to financial support from what was then the Bayerische Hypotheken- und Wechselbank. When the Alte Pinakothek was built, Rococo painting was frowned upon. François Boucher's 1756 'Portrait of Madame de Pompadour', Louis XV's mistress, is symbolic of the final decades of the *ancien régime* and entirely appropriate as a counterpole to Dürer's 'Four Apostles'.

The tour is not over yet, not by a long way … On the ground floor, the chronology starts afresh with German and Netherlandish paintings of the fifteenth and sixteenth centuries. This is where the great German altarpieces of the Middle Ages are displayed, having been brought to the museum following the dissolution of the monasteries. Here, too, is the home of the world's largest collection of works by Jan Brueghel the Elder – also known as Flower Brueghel or Velvet Brueghel. MARTIN SCHAWE

François Boucher, Portrait of Madame de Pompadour, 1756 (detail) | Loan from the Collection of HypoVereinsbank, Member of UniCredit

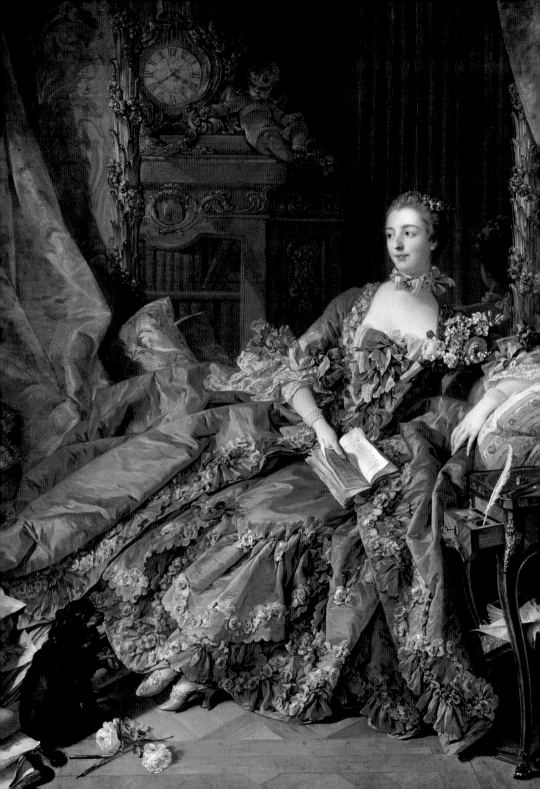

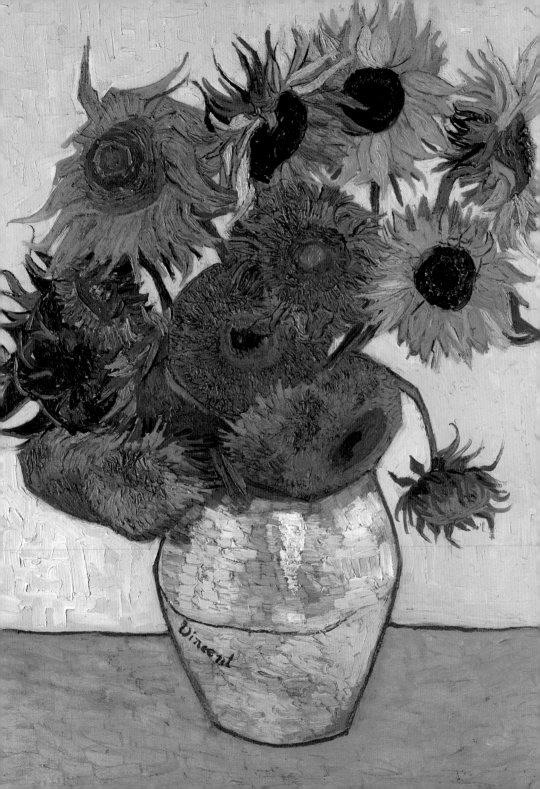

Munich
Neue Pinakothek

Barer Strasse 29, 80799 Munich, entrance Theresienstrasse | T +49 (0)89 23805 195 |
Open daily except Tuesdays | Disability-friendly access | www.pinakothek.de/neue-pinakothek

From Goya to van Gogh – the Neue Pinakothek in Munich is one of the few galleries in the world to be devoted exclusively to art of the nineteenth century. With paintings by Goya and David, Gainsborough and Turner, Caspar David Friedrich and Max Liebermann, Manet and Cézanne, the collection comprises an impressive number of unique masterworks. Nowhere else can the artistic riches of a single century be experienced in such concentration and high quality as at the Neue Pinakothek in Munich's art district, the Kunstareal.

For some visitors the name 'Neue Pinakothek' may at first seem misleading. Particularly since the opening of the Pinakothek der Moderne, people have often confused the two, as 'Neue' – which, after all, means 'new' – was and still is associated with the presentation of contemporary or modern art. This association is in fact not entirely misguided. The Neue Pinakothek was built opposite the gallery of the Old Masters, the Alte Pinakothek (founded in 1836), between 1846 and 1853. It was the world's first museum of contemporary art and opened its doors to the public on 25 October of the latter year. And now, after more than 160 years, the name is firmly established. Initially the adjectives were just descriptive: it was the 'neue königliche Pinakothek' or 'new royal art gallery' (both written in lower case). Between 1853 and 1920 the title pages of the inventories of paintings raised these adjectives to the status of part of the name, spelt with capital letters: first 'Königlich Neue Pinakothek' and finally 'Neue Pinakothek', the name by which the gallery is known today.

As an institution the Neue Pinakothek is a foundation of King Ludwig I of Bavaria. It should be seen in the context of numerous other initiatives undertaken by the art-loving ruler, 'the spectrum of which ranges from creating places of national historical memory – in the form of the Ruhmeshalle and Walhalla – to establishing various cultural buildings such as the Glyptothek and royal library, and all the way to the construction of monasteries and churches' (H. W. Rott). Destined by Ludwig I to be a gallery 'for pictures painted in this and succeeding centuries', the foundation of the Neue Pinakothek was, in terms of cultural politics, a remarkable and significant step. It now placed the moral purpose of art on a level with the centuries-old function of princely display.

Vincent van Gogh, Sunflowers, 1888 (detail) | Inv. No. 8672

Auguste Rodin, Helene von Nostiz, 1907 | Inv. No. FV 11
Jacques-Louis David, Anne-Marie-Louise Thélusson, Comtesse de Sorcy, 1790 (detail) | Loan from the Collection of HypoVereinsbank, Member of UniCredit

The present was called upon to match the standards of the past and, indeed, to surpass them.

And so the Neue Pinakothek was one of the very first of the modern museums to take shape in the nineteenth century and assume the role for which it is still known: not only as a standpoint to safely view artworks from the past, but also, and rather more, to embrace the contemporary experience of art with all the risks, historical imponderables and stylistic contrasts involved. This is what makes the collection so special to this day, even though what was then contemporary art, which the institution was dedicated to presenting, is now itself acquiring the patina of age.

Within the context of the Bavarian State Painting Collections, the Neue Pinakothek is responsible for displaying the art of the nineteenth century. In doing so, it occupies a position between the Alte Pinakothek on the one hand, and the Pinakothek der Moderne and Museum Brandhorst on the other. The building, designed by Alexander Freiherr von Branca and opened in 1981, was erected on the site of its predecessor, which was badly damaged in the Second World War and demolished in 1949. Today, the Neue Pinakothek houses not only the art gallery, but also the Doerner Institut, library, workshops and Central Administration of the State Collections and Museums. Without exaggeration, it is in every sense the heart of the Bavarian State Painting Collections.

Currently the collection comprises almost 3,000 paintings and several hundred sculptures ranging from late Rococo and an international Neo-

Classicism to the early modern art at the turn of the twentieth century. Its masterpieces include paintings by Jacques-Louis David and Francisco de Goya, via Friedrich Overbeck, Caspar David Friedrich, Adolph von Menzel and Max Liebermann all the way to Gustave Courbet, Édouard Manet, Paul Cézanne and Vincent van Gogh. Paintings by Joshua Reynolds, Thomas Gainsborough, George Stubbs, John Constable and William Turner provide an exemplary overview of English painting of the late eighteenth and early nineteenth centuries – a collection unparalleled in continental Europe. Works by Lovis Corinth, Gustav Klimt and Egon Schiele round off the transition to the twentieth century. In 2014, with the support of friends and donors, it was possible to acquire Dietmar Siegert's extensive collection of some 10,000 nineteenth-century photographs taken in Italy.

The names listed above give some idea of the international range of the Neue Pinakothek collection, which sought early on to position itself in a European context – a policy due not only to the remit accorded to the gallery by its royal founder, Ludwig I, but also, and even more, to a complex history of acquisitions which benefited not least from the 'International Art Exhibition' established in 1869 in Munich's own 'Crystal Palace', the Glaspalast. In 1868,

Giacomo Caneva, Temple of Vesta in Tivoli, c. 1850

the year of King Ludwig I's death, the private collection displayed in the Neue Pinakothek consisted of 425 paintings, predominantly by German masters. In 1874, the Bavarian state began somewhat hesitantly to fulfil its remit to collect artworks by purchasing the works of contemporary artists. These were exhibited in the Neue Pinakothek with the permission of the royal family. In 1886, an annual purchasing budget of 10,000 marks was approved and raised just four years later to 90,000 marks. While the aim of this substantial budget was primarily to continue acquiring works by Munich artists, it was also becoming clear that the status of the picture gallery could only be asserted, as Prince Ludwig of Bavaria put it, if 'the best paintings from all over the world' were to be seen there.

The Neue Pinakothek finally achieved lasting world status with the acquisition by Hugo von Tschudi of French Impressionist paintings during his brief period in office as director-general of the Bavarian State Painting Collections at the beginning of the twentieth century. Given that, initially, purchase of the works from public funds was not allowed, after Tschudi's death in 1911 it was very much thanks to the concerted effort of his assistant Heinz Braune and numerous donors – including the Berlin collectors Eduard Arnhold and Paul

and Robert von Mendelssohn – that the Neue Pinakothek can now display an outstanding selection of French painting from the second half of the nineteenth century.

Among the great many masterpieces in this so-called Tschudi donation is Vincent van Gogh's 'Sunflowers'. It is doubtless the best-known work in the collection, a striking eye-catcher for visitors from all over the world who succumb to the spell of the work's colourful and, at the same time, radical beauty. The painting in the Neue Pinakothek is of course not the only version of this motif, but probably the most important. In the summer of 1888 van Gogh painted a number of sunflower still lifes to decorate his house in Arles. Here, in the sun-drenched south of France, he hoped to create a refuge for friends and like-minded people, a house for a community of artists who wanted to get away from the bright city lights of Paris and work on a new form of art. And so 'Sunflowers' is above all pictorially a symbol of friendship, yet one that reflects the vanity of human endeavour, for van Gogh's dream did not come true. After a quarrel with his friend Paul Gauguin, a disillusioned van Gogh parted ways with him and retreated to Auvers-sur-Oise in May 1890, where, in December that year, he took his own life in dramatic circumstances.

Caspar David Friedrich, Riesengebirge Landscape with Rising Fog, c. 1819/20 | Inv. No. 8858
William Turner, Ostend, 1844 (detail) | Inv. No. 14435

'Sunflowers' is not the only picture of friendship in the collection. Friedrich Overbeck's painting 'Italia and Germania', painted 60 years earlier, is more than a personal testimony to the bond between him and his fellow painter Franz Pforr. At the same time, the picture formulates the aesthetic aspiration that Ludwig I wished should be associated with a gallery of contemporary art. The history of how this formative work from the infancy of German Romanticism came to be painted demonstrates, too, the desire on the part of young artists to turn their backs on academicism in favour of a spiritual, indeed religious new direction in art. The pictures that Franz Pforr and Friedrick Overbeck wished to dedicate to each other gave allegorical expression to their shared view of art: Early German painting as Pforr's model, and the Italian painting of the early Raphael and the quattrocento as Overbeck's ideal.

The rejection of the constrictions of the academic rulebook, the search for a spiritual renewal of art and finally the yearning for southern climes – incompatible as the two paintings 'Italia and Germania' and 'Sunflowers' may seem, they have these motives in common. As such, they describe the dynamic tension running through the whole collection of the Neue Pinakothek. It is a unique authenticity, a contemporaneous experience of art that remains palpable to this day and lifts the art of the Neue Pinakothek above the level of a mere historical collection. After more than 30 years in which the gallery has welcomed a lively flow of visitors, the building now faces general refurbishment so that future generations may also visit and enjoy this unique collection of nineteenth-century art. JOACHIM KAAK

Munich
Schack Collection

Prinzregentenstrasse 9, 80538 Munich | T +49 (0)89 23805 224 | Open daily except Mondays and Tuesdays | www.pinakothek.de/sammlung-schack

Arcadian landscapes, figures from myths and legends, dwarfs and nymphs – it is a very special world of images that visitors will find themselves in when they enter this gallery in Prinzregentenstrasse. On display here are the paintings gathered together by the poet, translator and art collector Count Adolf Friedrich von Schack in the three decades after 1850: works by German-speaking artists of his day. Many of them, such as Arnold Böcklin, Anselm Feuerbach and Franz Lenbach, were still young and unknown at the time. As a collector's museum in its original state, it provides an unusually self-contained insight into the world of ideas of this era.

The collector was born in Schwerin in 1815, scion of a wide-branching, north German aristocratic family. While still a law student in Bonn, Heidelberg and Berlin, Schack already showed an intense interest in the languages and literature of Europe and the Orient, learning Arabic and Sanskrit as well as embarking on a translation of the ancient Persian epic by Ferdowsi. Extensive travels took him to Italy, Spain and the Near East. In 1851, he resigned from the Prussian civil service, and from then on lived as a freelance scholar and author. Three years later King Maximilian II of Bavaria invited him to Munich to join a circle of scholars and poets who, known as 'northern lights', were to make the city a centre of intellectual life. Schack accepted the invitation and in 1856 moved to the Bavarian capital, where he acquired a property on Brienner Strasse, which he later enlarged and turned into a prestigious residence. In Munich he began to take an interest in the visual arts and acquired his first paintings. His choice of works was based on the principle not to be guided by prevailing tastes but rather to follow his own judgement. He concentrated mainly on young, still largely unknown artists in whom he recognized potential and with whose pictures and themes he felt an affinity. He complemented the collection with copies of selected Old Masters which he commissioned in Italian and Spanish museums. In this way, by the late 1870s he had assembled some 270 paintings. He bequeathed them in his will, the first draft of which dates from 1874, to the Kaiser. When Schack died in 1894, Wilhelm II claimed his inheritance, but allowed the collection to remain in Munich, and in 1909 had a gallery built to house it. The collection has been here ever since.

Moritz von Schwind, The Morning Hour, c. 1860 (detail) | Inv. No. 11559

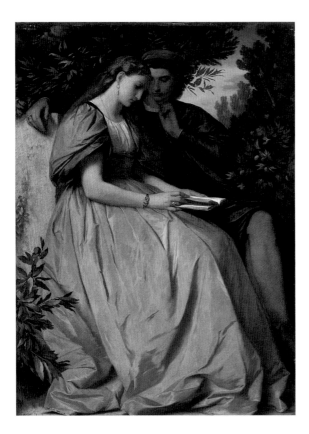

Anselm Feuerbach, Paolo and Francesca, 1864 | Inv. No. 11521

The rooms on the ground floor, which are largely cabinets of intimate character, display Italian and Greek landscapes as well as illustrations of fairy tales and legends from the German Middle Ages. The pictures invite the viewer to follow the collector on his virtual journeys to distant countries and times. Franz Ludwig Catel's veduta of the Greek theatre near Taormina presents a view of magnificent Mediterranean scenery with the sea and Mount Etna in the background. It also recalls the cultural experience enjoyed by Goethe when reading Homer on this site. Johann Georg von Dillis's enchanting vedute of Rome bring to life the view from the terrace of the Villa Malta over the Eternal City. Derived from the motifs of the Greece cycle in the Neue Pinakothek, Carl Rottmann's melancholy Greek landscapes invite us to reflect on the past greatness of this cradle of European culture. The collection includes more than 30 paintings by Moritz von Schwind, in which the artist unfolds an imaginary journey in pictures by way of motifs from German legend and literature. With

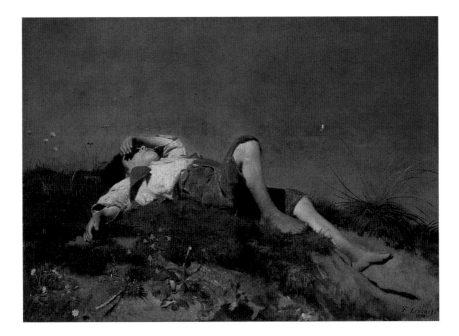

works like 'Die Morgenstunde', 'Rübezahl' and 'Des Knaben Wunderhorn' the paintings include many that are deeply rooted in the German collective pictorial memory. A room with works by Carl Spitzweg, the only genre painter of his time whom Schack held in high regard, displays examples not only of Spitzweg's fine sense of humour, but also imagined views of the Orient and Spain: for example 'Turks in a Coffee House' or 'Spanish Serenade'. The collection also includes some valuable coloured works on paper, such as Eugen Napoleon Neureuther's 'Memory of Villa Malta'. These are kept behind curtains on account of their sensitivity to light. Visitors are invited to draw aside the red curtain and to discover the works for themselves alone.

On display on the first floor are the principal works of the collection, namely those by Franz Lenbach, Arnold Böcklin and Anselm Feuerbach. Each of these artists is extensively represented: Feuerbach with eleven paintings and Böcklin with no fewer than 16. The poetic content – for Schack the *raison d'être* of all art – is conveyed in Böcklin's landscapes and figures in a number of ways. It is no longer idealized classical antiquity that comes to life in his works, but the nearness to nature, the sometimes wild and dark side of the myths. Feuerbach devotes himself to sublime themes of Western art by referring back to motifs of Italian literature: 'Paolo and Francesca' illustrates an episode from

Dante's *Divine Comedy*; 'Laura in the Church' depicts Petrarch's first encounter with his goddess – the moment when unrequited love turns him into a poet. 'Ariosto's Garden' conjures up an ideal artistic existence at a Renaissance court, where the poet is honoured as a central figure of courtly society. In contrast to these idealized pictorial worlds, Franz Lenbach's 'Shepherd Boy' presents a motif from life as it was at the time of the artist: a sun-tanned boy lying in the grass whom Lenbach would have observed in the surroundings of his home town of Schrobenhausen and captured in studies. For Schack, however, this work also contained a reference to a tradition of the Old Masters in that he was reminded of the famous depictions of children by Murillo in the Alte Pinakothek.

The tour of the first floor ends in the splendid Hall of Copies, which was refurbished in 2009 and where 19 original-size copies of famous paintings of the Venetian Renaissance are exhibited. Lenbach's copies of masterpieces such as Titian's 'Urbino Venus', his 'Portrait of Emperor Karl V' and August Wolf's monumental copy of Giovanni Bellini's altarpiece in S. Zaccaria are among the highlights in this room. The Hall of Copies is also of some significance in recent political history: until 1993 it belonged to the neighbouring State Chancellery, and was where the Bavarian state government held its cabinet meetings.

The second floor, which is due to reopen in the spring of 2016, guides visitors to Spain, a country often visited by the collector and one to whose art and culture he devoted extensive studies. Paintings by Fritz Bamberger and Eduard Gerhardt showing the landscapes of Castile and Andalusia and including views of Granada and the Alhambra conjure up the exotic appeal of these witnesses to Moorish culture on the Iberian Peninsula. HERBERT ROTT

Arnold Böcklin, Villa at the Seaside II, 1865 (detail) | Inv. No. 11536

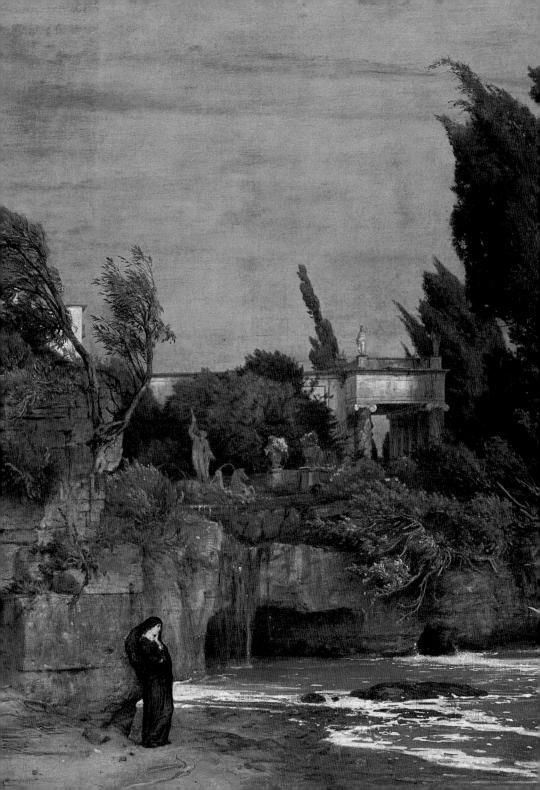

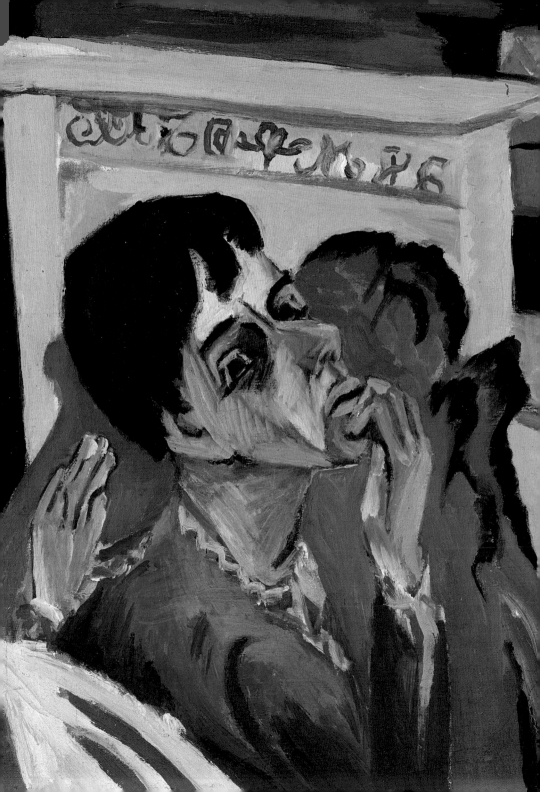

Munich
Modern Art Collection in the Pinakothek der Moderne

Barer Strasse 40, 80333 Munich | T +49 (0)89 23805 360 | Open daily except Mondays | Disability-friendly access | www.pinakothek.de/pinakothek-der-moderne

The Pinakothek der Moderne is one of the leading European museums of twentieth- and twenty-first-century art and design. It houses four collections which have all grown over the decades: the State Collection of Prints and Drawings, the Design Museum, the Architectural Museum of Munich's Technical University, and the Modern Art Collection of the Bavarian State Painting Collections. As such, the complex thus offers a unique, constantly expanding panorama of our age.

The Pinakothek der Moderne thrives on the interplay of art and architecture, graphics and design, style and media that unfolds in its rooms. It begins with the European avant-garde movements: the French Fauves and Cubists, Italian Futurists, German Expressionists and the Bauhaus, Neue Sachlichkeit and Surrealism. One of the earliest acquisitions was at the same time a milestone in modern art: the 'Still Life with Geraniums' dating from 1910. It was one of the first pictures by Henri Matisse in public ownership and is a paradigm example of the emphasis on ornament and flat areas of colour.

In the adjoining rooms the eruption of colour continues with the 'Brücke' painters from Erich Heckel to Karl Schmidt-Rottluff. After the Second World War, noteworthy donations and purchases led to Expressionism becoming a major focus of the collection, which currently comprises 50 works. This is why today Munich possesses Germany's largest collection of paintings by Ernst Ludwig Kirchner – 19 in all, including such important works as 'Circus' (1913) and 'Self-portrait as an Invalid' (1918/30), which reflect the artist's time both in Berlin and Davos. The group of Expressionists known as the 'Blauer Reiter' is represented with such masterpieces as Franz Marc's large-format 'Tyrol' and Wassily Kandinsky's 'Dreamy Improvisation'.

The collection also possesses 39 works by Max Beckmann, more than any other museum in Europe. Starting with 'The Great Death Scene' from 1906, visitors can experience an unusually broad spectrum of his œuvre all the way through to 'Woman with Mandolin', painted in New York in 1950. The heart and climax of this collection remains, though, 'Temptation' (1936/37), one of the only two triptychs by Beckmann still in Germany.

Ernst Ludwig Kirchner, Self-Portait as an Invalid, 1918/30 (detail) | Inv. No. 15580

Paul Klee, the twentieth century's most significant German-speaking artist after Kirchner and Beckmann, is represented in the Pinakothek der Moderne with 20 pictures. Leading works such as 'Full Moon' and 'Limits of Understanding' document his time in Munich and the important years at the Bauhaus.

Klee and his œuvre form the bridge between Expressionism and Surrealism. This latter movement has been a focus of the gallery since the 1980s, with the acquisition of the Wormland Collection. René Magritte's pioneering 'Key to Dreams' (1927), Salvador Dalí's 'Riddle of Desire' (1929) and central works by Max Ernst, such as 'Fireside Angel' (1937), represent decisive stages of this epoch.

Equally noteworthy is the range of Pablo Picasso's works spanning the six decades from 1903 to 1963. The chronological beginning is marked by 'Madame Soler', painted during the Blue Period, and the end by 'The Painter and His Model' (1963). Picasso's stylistic development in the field of depictions of women can be traced particularly well in the Pinakothek.

It was with the acquisition of Francis Bacon's 1965 triptych 'Crucifixion' that the collection of post-1945 art began in 1967. Since then, in constructive dialogue with the museum, a committed circle that includes the friends of the museum (Galerieverein), now known as PIN. Freunde der Pinakothek der

Moderne, has promoted the acquisition of contemporary works. Among them are those that were purchased despite debate. With a keen eye for quality it has been possible to purchase individual works by the European artists Joseph Beuys, Georg Baselitz, Sigmar Polke, Blinky Palermo, Jörg Immendorff, Arnulf Rainer and Wolfgang Laib as well as by the Americans Franz Kline, Willem de Kooning, Robert Motherwell, Jasper Johns, Robert Rauschenberg, Morris Louis and Andy Warhol. In many cases sufficient numbers of their works have subsequently been acquired to document the whole œuvre of the artist in question.

Thematic focuses have also been created successively through artist rooms. A milestone in this process was the acquisition in 1986 of the room-filling work 'The End of the 20th Century' (1983) by Joseph Beuys. Since 2002, American Minimal Art has become a focus to a degree otherwise unknown

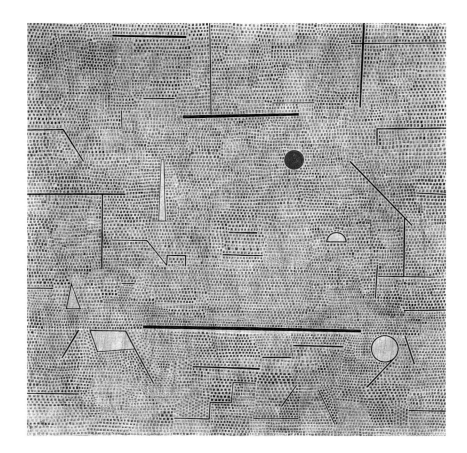

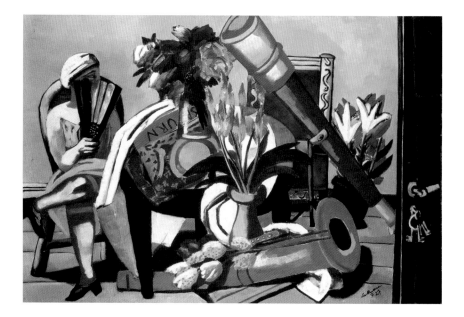

in Europe. This includes the acquisition of an installation with 16 wall-mounted and three floor works by Donald Judd and also a room with four '"monuments" (for V. Tatlin)' by Dan Flavin. This led to the creation of a whole room conceived by Flavin. In 2003, the museum persuaded Fred Sandback to create five of his sensitive installations with yarn thread for different rooms in the museum. The project by Walter De Maria for the Türkentor, which was implemented in 2009 in collaboration with the Brandhorst Collection and the Pinakothek der Moderne Foundation, should also be mentioned in the context of these conceptual endeavours (see pp. 67–68).

Thanks to a substantial donation from a private foundation, it has been possible to extend the field of European art with the addition of 280 multiples by Joseph Beuys. In the recent past, donations of early works in bronze by Beuys expanded the collection still further and in doing so created another impressive focus. Further important additions have come from the donation of 40 paintings by Arnulf Rainer in 2012 and the extension of the complex of works by Georg Baselitz with two recent large-format paintings from his 'Remix' series.

Yet a further gain of extraordinary importance has been the permanent loan of the Stoffel Collection, which has greatly enlarged the museum's stock of international art of the 1980s.

Max Beckmann, Large Still Life with Telescope, 1927 | Inv. No. 13454

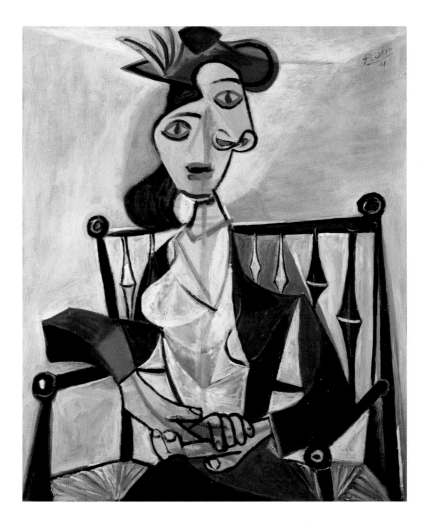

A tour of the Modern Art Collection reveals the extent to which art of the present day is characterized by a diversity of hybrid media. The achievements of Modernism are critically questioned and often continue their evolution in the form of intermedia works. At the same time, artists such as Luc Tuymans, Peter Doig and Neo Rauch have since the 1990s given new impetus to a genre that only a generation earlier was struggling to maintain its artistic respectability – namely painting. While they were finding their way to new forms of figurative art, artists such as Wade Guyton, who was born in 1972 and uses an ink-jet printer for his work, stand for an extended definition of 'painting'.

The spectrum of sculptural works on display is now no less broad and ranges from reliefs, collages and assemblages all the way to light-works by artists such as Olaf Nicolai, Henrik Olesen, Steven Claydon and Ian Kiaer. Performative and photographic concepts, for instance by Roman Ondák and Gillian Wearing, also address positions on sculptural issues. The installations of post-1945 art continue in works such as 'Himalaya Goldstein's Living Room' by Pipilotti Rist (1998), the 'Double Garage' by Thomas Hirschhorn (2002) and 'Silent Factory' (2003) by Mark Manders.

Work on building up the collection of media art has been in progress since 1998. With Bruce Nauman, Gary Hill, Bill Viola, Marcel Odenbach and Tony Oursler, some of the leading pioneers of video art are represented with characteristic works. In contrast, artists such as Rineke Dijkstra, Kutlug Ataman, Johan Grimonprez and Bjørn Melhus belong to a generation that grew up with television and focus on the process of new narrative forms. In recent years Fiona Tan, David Claerbout, Yael Bartana, Omer Fast and others have been continuing with video art. The donation of the media section from the internationally renowned Goetz Collection to the state of Bavaria has facilitated a substantial enlargement of this area.

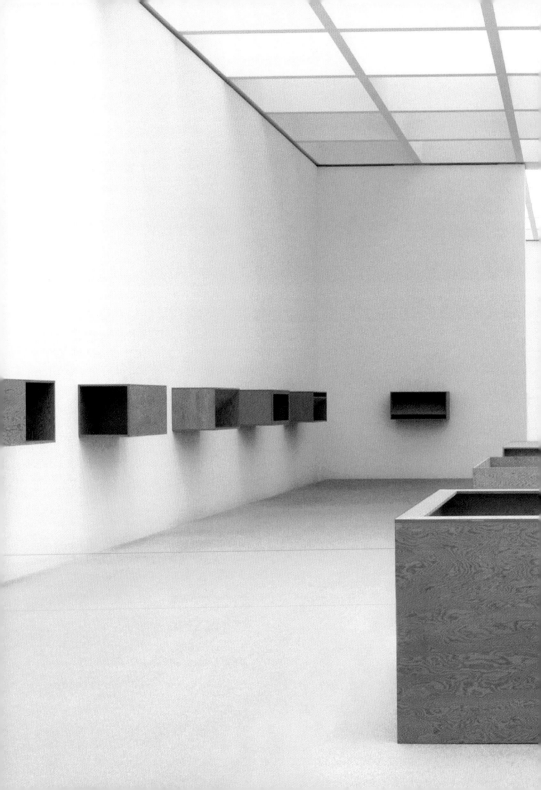

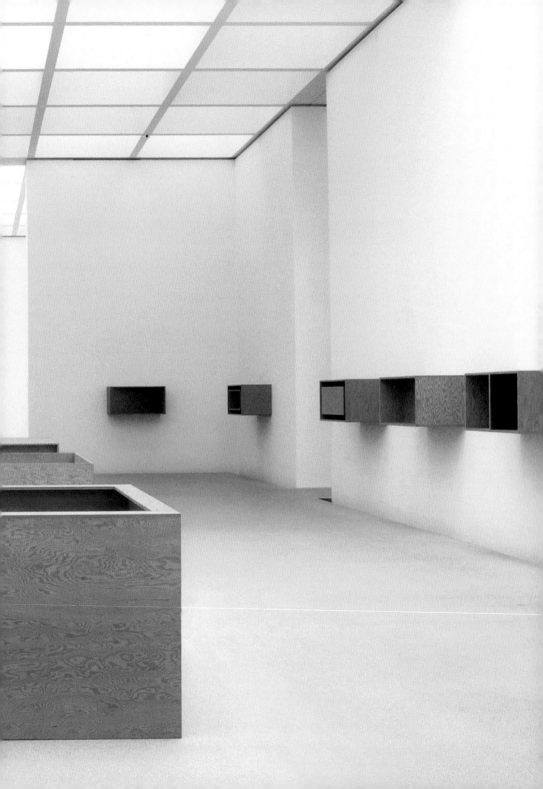

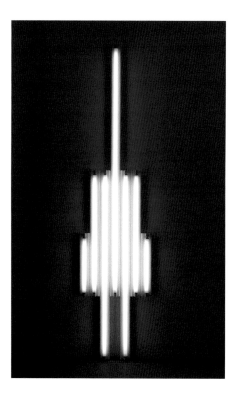

Dan Flavin, 'monument' (for V. Tatlin), 1969 | Loan from Stiftung Galerie-Verein zur Förderung staatl. bayerischer Museen | Loan from Donald Judd. Untitled, 16 unit wall-boxes, 1978 | Inv. No. B 931 1/16 – 16/16
Previous double page: Donald Judd. Untitled, 16 unit wall-boxes, 1978 | Inv. No. B 931 1/16 – 16/16

Photography in the Modern Art Collection encompasses the whole of the twentieth century and the twenty-first century to date. Starting in 1990, contemporary art photography was initially collected sporadically, the items including outstanding individual works by Andreas Gursky, Jeff Wall, Hiroshi Sugimoto, Günther Förg and Thomas Demand. The opening of the Pinakothek der Moderne in 2002 promoted the creation of a section devoted exclusively to photography as a form of artistic expression in its own right. It is based on a collection compiled in association with Siemens AG, which was presented to the Pinakothek der Moderne when it opened. It comprises some 850 works by 60 contemporary photographers, mostly from Germany and the USA, including groups of works by Robert Adams, William Eggleston, Michael Schmidt, Stephen Shore, Nicholas Nixon and Martin Parr. In 2004, 149 works were obtained from the photographic collection of Allianz, including seminal works by the Düsseldorf School. Through purchases and donations it has been possible in recent years to enrich the collection of contemporary photography, which now boasts almost 3,000 items. Among them is a room-filling

installation by Wolfgang Tillmans and extensive series by Arno Fischer, Boris Mikhailov, Ursula Schulz-Dornburg, Nobuyoshi Araki, Larry Clark and Zoe Leonard.

In 2010, thanks to the Ann and Jürgen Wilde Foundation, the museum acquired not only an outstanding collection of photography from the 1920s and 1930s. Together with the archives of Karl Blossfeldt and Albert Renger-Patzsch, which include the two photographers' negatives and archival documents, it is hoped the collection, comprising several thousand works, will form the basis for research into the history of photography. In order to extend the donation both in range and depth, the Modern Art Collection also acquired 75 photographs by Karl Blossfeldt as well as 80 works by August Sander, some of which belong to the groundbreaking portrait volumes 'People of the Twentieth Century'. INKA GRAEVE INGELMANN, OLIVER KASE, BERNHART SCHWENK, CORINNA THIEROLF

Jeff Wall, An Eviction, 1988/2004 | Inv. No. 15319

Munich
Museum Brandhorst

Theresienstrasse 35a, 80333 Munich | T +49 (0)89 23805 2286 | Open daily except Mondays | Disability-friendly access | www.museum-brandhorst.de

The spectacular façade of the Museum Brandhorst is without a doubt a real eye-catcher. But this is by no means all there is to see. Awaiting you inside is an outstanding collection of artworks from the past 50 years: Mike Kelley, Bruce Nauman, Sigmar Polke, Cy Twombly and Andy Warhol are just some of the many artists to be discovered here.

The history of art museums is relatively short when compared with the history of art itself. For a long time, beholding and engaging with artworks was something done almost exclusively in private and undertaken in mainly courtly or religious contexts. It was only in the late eighteenth century that a change set in. Gradually art was transferred to public museums and so made accessible to a wider public. In Munich, for example, the art treasures of the ruling Wittelsbach dynasty were presented from around 1780 in the Hofgarten Gallery, a predecessor of the Alte Pinakothek. Today, it is primarily in museums run by public bodies that we come into contact with art. However, civic patronage and important private collections still form the core of numerous public institutions – as is the case with the museums named after Peggy Guggenheim or Peter and Irene Ludwig. Similarly, the Museum Brandhorst stands in this tradition of the 'collector's museum'. Opened in 2009, it houses the formerly private collection of Udo and Anette Brandhorst. In 1993, the couple set up a foundation to promote the art of the twentieth and twenty-first centuries, donating their own collection to it. With the inauguration of the museum the collection was then transferred to the public domain. Since then, the Bavarian State Painting Collections have been responsible for the care and presentation of the collection as well as academic research into the artworks.

It was back in 1971 that the Brandhorsts started to acquire artworks. They began with typical representatives of modern art, such as Joan Miró, Pablo Picasso and Kazimir Malevich. But soon the collectors turned their attention to a much more recent period of art, and it is this that has fundamentally changed our view of what art is and can be about. For in the 1960s and early 1970s these questions were explored: pop culture ruled supreme. Totally new materials and production methods, hitherto seen as not 'artworthy', found

Bruce Nauman, Mean Clown Welcome, 1985 | Inv. No. UAB 299

Alex Katz, Paul Taylor Dance Company, 1963/64 | Inv. No. UAB 207
Jannis Kounellis, Untitled (Rimbaud), 1980 | Inv. No. UAB 260

their way into museums. Art left the galleries and moved into the public space, both urban and rural. The status of the object was seriously questioned and the purely conceptual 'idea' of the work allowed to come to the fore. This innovative and, to this day, challenging spirit is reflected in major works of Minimal Art, Pop Art and Arte Povera, which form the heart of the Brandhorst Collection. That such a figure as Andy Warhol – the co-founder and surely most prominent exponent of Pop Art, who like no other blurred the distinction between everyday and 'high' art – is represented with more than 100 works testifies to the collectors' concentration on a group of artists as select as they were important. A further highly prominent place is dedicated to Cy Twombly. Second only to the Twombly Gallery in the Menil Collection in Houston, Texas, the Brandhorst Museum possesses one of the largest collections of his works anywhere in the world: more than 170, comprising photographs, prints, sculptures and paintings. Twombly's poetic œuvre, seen by some as provocative, occupies the whole of the top floor.

The Brandhorst Collection has developed from a profound engagement with the most influential artists of our times. It is oriented less towards re-

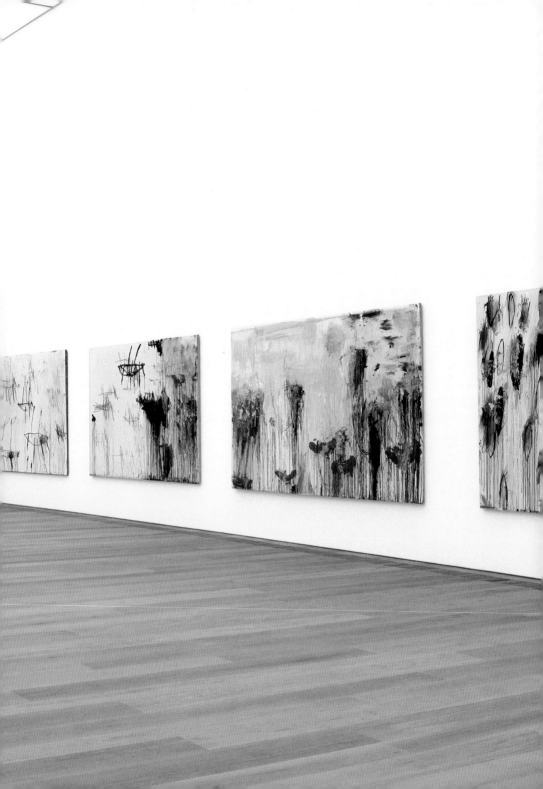

flecting superordinate tendencies than to achieving deeper insights into individual artistic positions. When the museum opened, the collection already possessed significant numbers of works by the American artists Robert Gober, Mike Kelley, Jeff Koons, Cady Noland and Christopher Wool – in other words, key figures of the so-called Critical Postmodernism of the 1980s and 1990s. This expansion into the field of contemporary art continues to this day. With Kerstin Brätsch, Guyton\Walker, Seth Price, Albert Oehlen, Louise Lawler, R. H. Quaytman and Heimo Zobernig, some of the most exciting artists of the past two decades have now found their place in the collection. And media art, too, the youngest genre of the visual arts, has begun to occupy a larger part of the Brandhorst portfolio. The collection now comprises more than 1,000 works and, as such, provides an impressive basis for discussing central issues surrounding contemporary art, the most pressing of which is the relationship between art and the flood of images in the media. This discussion takes place in the context of presentations of the collection and temporary exhibitions that constantly reveal new associations between central artistic positions of the post-1960s era and the current discourse. Rigorous orientation towards

Andy Warhol, Self-Portrait, 1986 | Inv. No. UAB 598
Previous double page: Cy Twombly, Lepanto I – XII, 2001 (partial view) | Inv. No. 469 – 480

contemporary art by this youngest institution of the Bavarian State Painting Collections is in tune with the history of the Brandhorst Collection, which from the outset has always been a reflection of its own time.

When a private collection is transferred to the public domain there is always a change in how it is perceived and inevitably in its character, too – not least of all by dint of the new physical context in which it is displayed. The Anglo-German architect duo Sauerbruch Hutton, winners of many awards, have taken full account of this aspect by designing different types of galleries in the Museum Brandhorst. These vary all the way from intimate cabinets reflecting the way art is observed in private rooms to generously proportioned halls that provide space for some of the museum's most prominent works. This is undoubtedly at its most striking in the presentation of Cy Twombly's twelve-part 'Lepanto' cycle, which was originally painted for the 2001 Venice Biennale. A polygonal exhibition space was designed especially to house it. The fact that architectural considerations have focused on providing optimum conditions for viewing art is also reflected in the decision to illuminate most of the museum's rooms with daylight. The inviting and varied design of the interior finds its counterpart in the spectacular exterior of the building. Located at the north-east end of the Kunstareal, it fits in well with the dense architecture

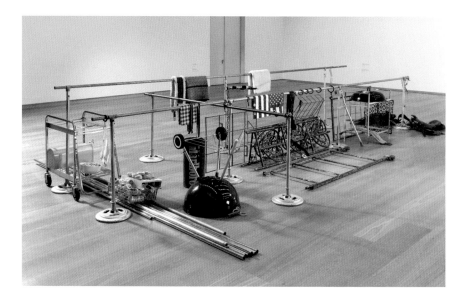

of the Maxvorstadt district. With its cladding of 36,000 multicoloured ceramic rods, the façade not only highlights the varied colour world of its surroundings but, thanks to its acoustic insulation, also serves to lessen the noise. This façade of the Museum Brandhorst has become one of the most photographed motifs within the Kunstareal, a sure sign that it provides visual pleasure not just for us. PATRIZIA DANDER

Cady Noland, Deep Social Space, 1989 | Inv. No. UAB 323
Kerstin Brätsch, Unstable Talismanic Rendering 19 (with gratitude to master marbler Dirk Lange), 2014 | Inv. No. UAB 908

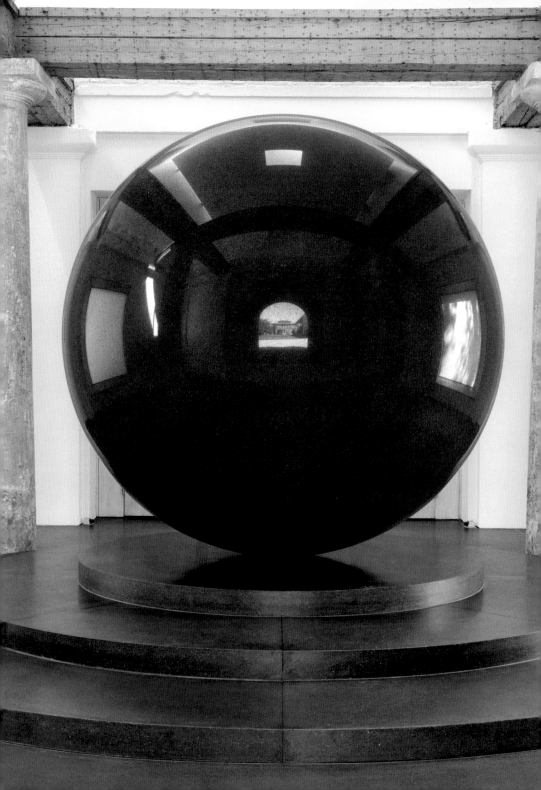

Munich
Türkentor: Walter De Maria, 'Large Red Sphere', 2010

Türkenstrasse 17, 80333 Munich | Open daily except Mondays | www.pinakothek.de/tuerkentor

Ever since the 1960s the American artist Walter De Maria has been regarded as an outstanding personality of worldwide repute. With simple geometric forms in restrained arrangements he has created room installations that deal with complex contexts. Along with his famous 'Lightning Field' in New Mexico (1977), the 'Vertical Earth Kilometer' in Kassel (1977) and 'Seen/Unseen Known/Unknown' on the island of Naoshima in Japan (2000), his site-specific works include the 'Large Red Sphere' in Munich's Türkentor (2010). This is yet another example of Walter De Maria's endeavour to impart to us the experience of the unfathomable order of nature.

The 'Large Red Sphere' in the Türkentor occupies a central position in the art district known as the Kunstareal. Since 2010, it has been located in a fragment, disused for decades, of the former Prinz Arnulf Barracks built in the nineteenth century and largely destroyed in the Second World War. The gate acquired its popular name from the adjoining street, Türkenstrasse. It is situated not only between the Pinakothek der Moderne and Museum Brandhorst, but also directly opposite the Klenze Portal, the original main entrance to the Alte Pinakothek. As such, the Türkentor acts as a kind of hinge in city-planning terms. The dilapidated structure was redesigned in close collaboration between Walter De Maria and the Berlin architects Sauerbruch Hutton in such a way that sculpture and architecture enter into a mutual relationship.

The 'Large Red Sphere' confronts the visitor with a basic geometric form in which figure and context are reflected. The sphere is the universal symbol of the world, celestial bodies, cosmic and eternal forces, and holistic perfection, while its physical properties – material, size and weight – evoke a strong physical presence. The red granite sphere is 2.6 metres in diameter and weighs 26 tons. The sculpture commands a particular presence thanks to two elements: on the one hand, the three-step plinth, designed by the artist, on which the sphere rests, and, on the other, the four surrounding columns that support a positively archaic-looking beam construction with numerous nails – remains of the former intermediate ceiling of the Türkentor. The contrast between the perfect,

Walter De Maria, Large Red Sphere, 2010 | Inv. No. UAB 666

high-gloss sphere and the spatial shell with its multiplicity of elements, forms and materials lends the installation its striking character. In addition, the reflecting surface of the 'Large Red Sphere' stands in marked contrast to its material compaction. In the duality between interior and exterior and between the three-dimensional form and – only ever limited – visibility, which depends on the beholder's position, lies one of the essential preconditions for observing Walter De Maria's work and experiencing its evocative force. The installation of the 'Large Red Sphere' in an otherwise entirely different cubic space, one that preserves so many traces of the past, marks a place of aesthetic experience and historic actualization. CORINNA THIEROLF

The Bavarian State Painting Collections
A photo essay by Martin Fengel

Munich, Alte Pinakothek

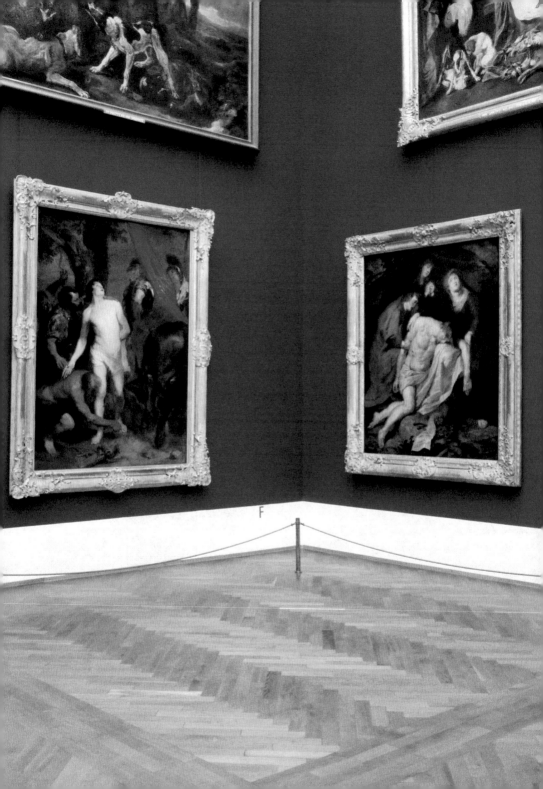

Olympia 1839

Munich, Neue Pinakothek

Adolf Friedrich Graf von Schack

Munich, Schack Collection

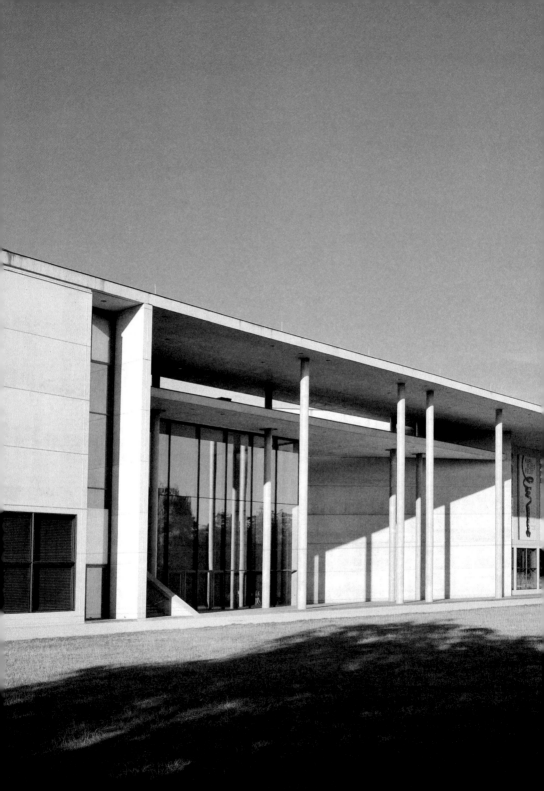

Munich, Pinakothek der Moderne

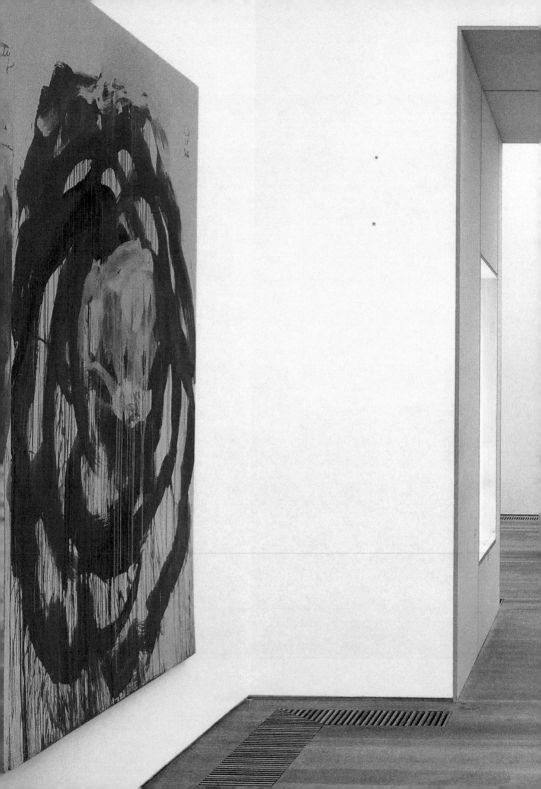

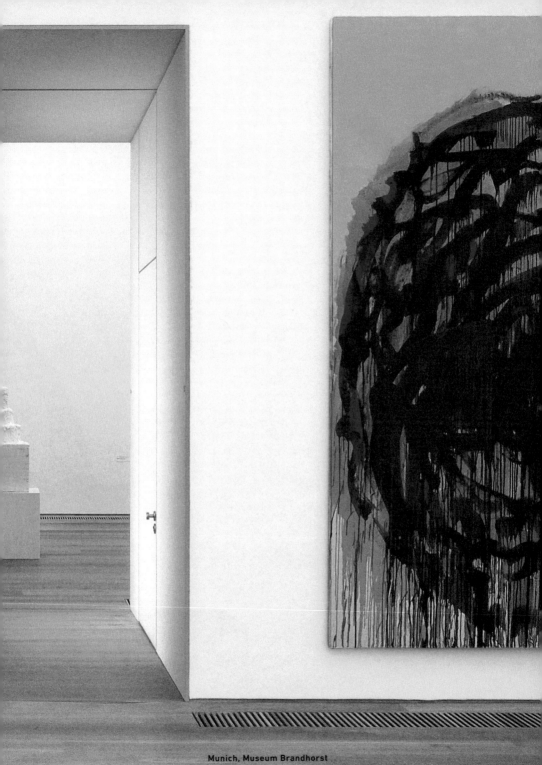

Munich, Museum Brandhorst

Augsburg, State Gallery in St Catharine's Church

Above: Bayreuth, State Gallery in the New Palace
Right: Oberschleissheim, State Gallery in the New Palace in Schleissheim

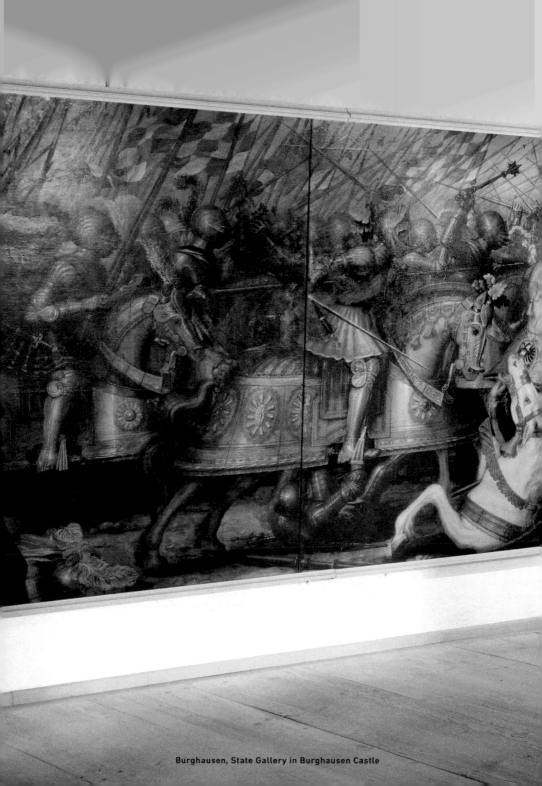

Burghausen, State Gallery in Burghausen Castle

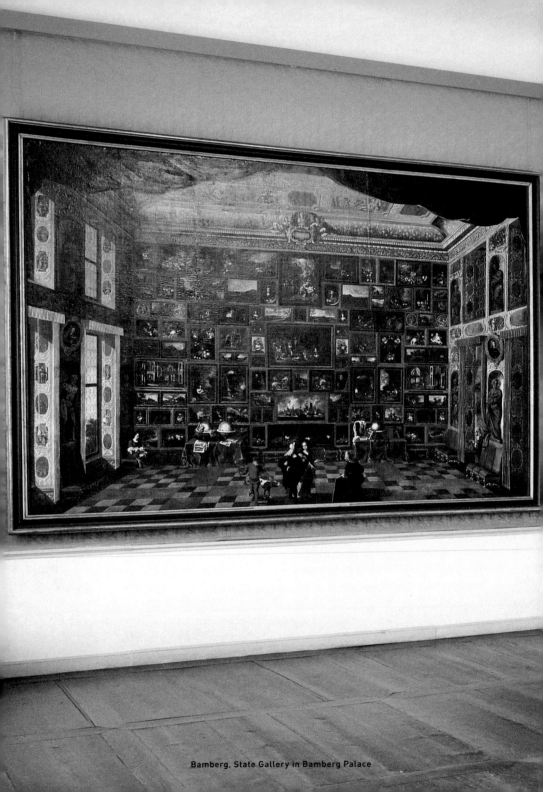

Bamberg, State Gallery in Bamberg Palace

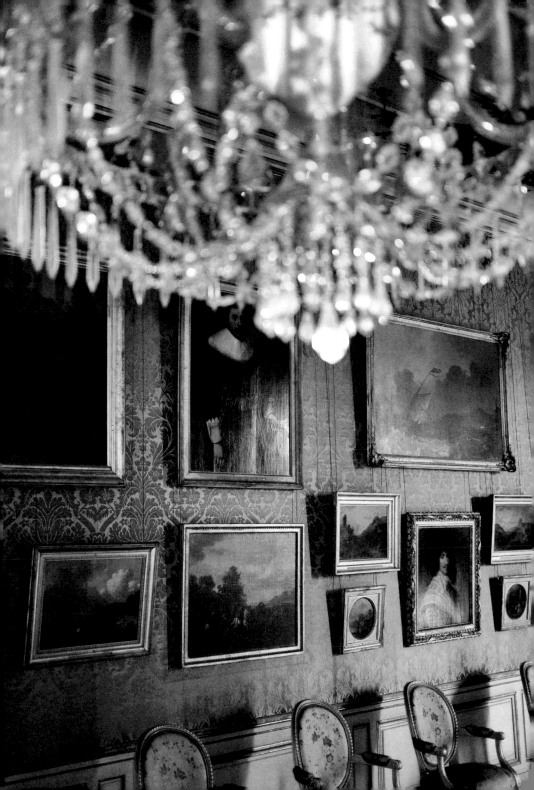

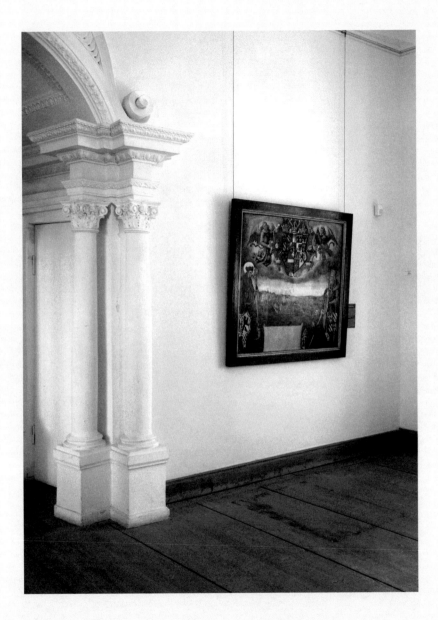

Above: Füssen, State Gallery in the Hohes Schloss
Left: Ansbach, State Gallery in the Ansbach Residenz

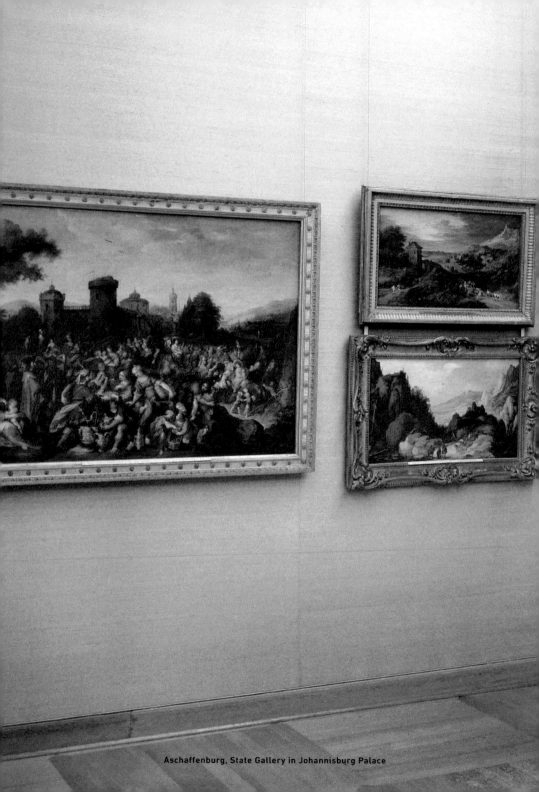

Aschaffenburg, State Gallery in Johannisburg Palace

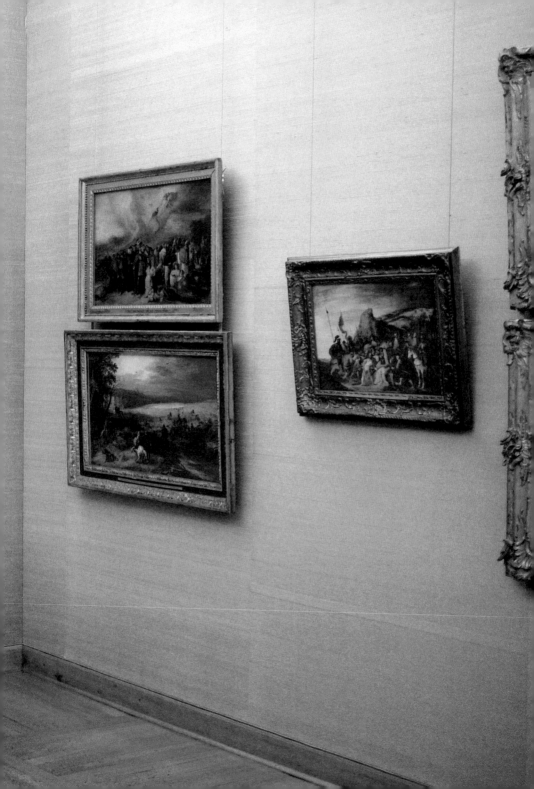

Ottobeuren, State Gallery in the Benedictine Abbey

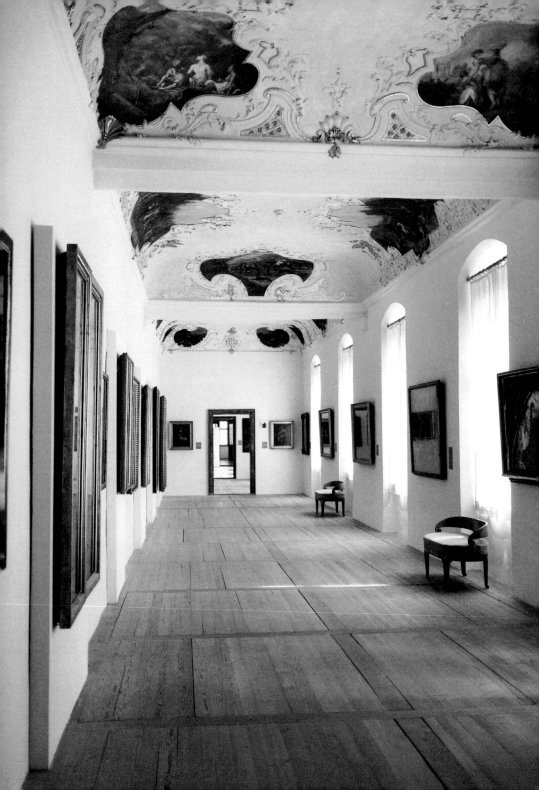

Neuburg, State Gallery in Neuburg Palace

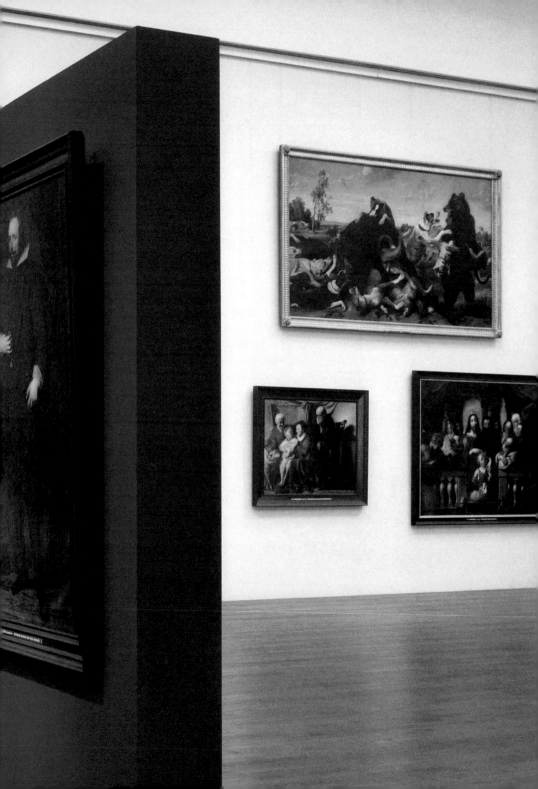

Above: Augsburg, State Gallery of Modern Art in the Augsburg Glaspalast
Left: Tegernsee, Olaf Gulbransson Museum

Martin Fengel (born 1964)

studied photography in Munich. After assistant posts in New York he
returned to the Bavarian capital, where he now lives and works. In
the summer of 2015 he set out on a journey for a photo blog that took
him to the museums and branch galleries of the Bavarian State Paint-
ing Collections. We offer here a selection of the resulting photographs.

Ansbach
State Gallery in the Ansbach Residenz

Promenade 27, 91522 Ansbach | T +49 (0)981 953 8390 | Open daily except Mondays | Disabled-friendly access | www.pinakothek.de/staatsgalerie-ansbach

In the festive gallery at the Ansbach Residenz, opposite the window façade with its large mirrors, there hang selected paintings of Dutch, Flemish and French Baroque art. An additional picture cabinet provides an insight into the work of local court artists. Here, one can get some idea of the glamour and importance of princely collecting in the eighteenth century.

In 1771, Margrave Alexander of Brandenburg-Ansbach, who was also Margrave of Brandenburg-Bayreuth, had three rooms on the first floor of the palace in Ansbach merged to form a gallery, which also included a 'picture cabinet' and an anteroom. The margrave supplemented his Ansbach collection with, among other things, works from his other territory of Bayreuth. In 1791, he abdicated in favour of the kingdom of Prussia, and went into exile in England, taking some of the pictures with him. The former margravate came under Bavarian rule in 1806. It was not until 1841 that the head of the Central Directorate of Picture Galleries, Johann Georg von Dillis, drew up an inventory of the Ansbach collection. However, in the process he listed not only the works in the gallery itself, but also those in other rooms in the palace, which for the most part can still be seen there as permanent loans from the Bavarian State Painting Collections. From the 1870s onwards, there were numerous changes to the collections on display. The current presentation accords almost completely with the comprehensive new concept drawn up in 1971.

Even though it continues the tradition of the margrave's gallery, only some of the works exhibited in the State Gallery today come from the old Ansbach collection. These are largely limited to the cabinet, which is still in use. With paintings by Johann Carl Zierl, Johann Christian Sperling and Friedrich Gotthard Naumann, it is devoted exclusively to the art of the Ansbach court painters. Some of the pictures on display were formerly exhibited in the main gallery, including 'Vestal Virgin (Spring)' and 'Maenad (Autumn)', two allegories by Naumann. A description by the privy councillor Johann Bernhard Fischer dating from 1786 mentions these as outstanding works 'painted with much grace'.

Jean-Baptiste Le Prince, The Secret Lover, 1774 (detail) | Inv. No. 39

Today, three schools of European Baroque painting are displayed on the three wall sections of the main gallery: coming from the cabinet, visitors will see, on the left, first the Dutch, then the Flemish and finally the French paintings. While the hanging of the pictures in several rows may recall the close packing associated with Baroque galleries, the strict separation by schools was a museum principle of the nineteenth century, and is maintained by most picture galleries to this day. Works of various provenance from the extensive stocks of the Bavarian State Painting Collections are assembled here – a number of them having come originally from the Wittelsbach galleries in Mannheim and Zweibrücken. Hung on the end wall is the only picture from the old Ansbach collection still in the long gallery: the 'Idealized Italian Landscape' by Jan van der Meer. The aim of the presentation is to evoke, in the historic rooms, by means of selected pictures of high quality, the prestigious character and splendour of a princely art collection in the eighteenth century without actually copying one.

The focus on Dutch and Flemish painting matches the importance of these schools in what was once the margrave's collection. The Flemish school is represented by opulent still lifes, portraits, and works by Frederik Bouttats, a follower of Brueghel. There are 20 paintings representing Dutch art – ranging from Ludolf Backhuysen's outstanding seascape 'The Roads of Plymouth' to portraits by Jan van Ravesteyn. Jan Both's brilliant 'Roman Ruins with Card Players' probably dates from the end of his trip to the Eternal City.

Jan Both, Roman Ruins with Card Players, c.1640 | Inv. No. 1016

Only a few works by French painters were included in the margravial gallery in the eighteenth century. But the extent to which pictures from France were appreciated in Ansbach is demonstrated by an important purchase. In 1728, Margrave Carl Wilhelm Friedrich acquired direct from Jean-Baptiste Oudry in Paris two large animal paintings for decorative purposes that can still be seen in another part of the palace today. In the course of a recent reorganization, the State Gallery received an exquisite ensemble of ten works by French painters including Hyacinthe Rigaud, Hubert Robert and Jean-Baptiste Greuze. 'The Secret Lover' by Jean-Baptiste Le Prince, one of the gallery's main works, was transferred from the Alte Pinakothek, having come originally from the gallery in Zweibrücken. The picture shows an elderly man asleep and clutching a ribbon attached to a young woman seated next to him – his daughter or wife? – who is exchanging sad glances with a young man. Here, Le Prince is taking up the genre, which originated with Antoine Watteau, known as the 'fête galante'. However, his presentation of the scene itself is more anecdotal. Those so inclined could refer to this painting to dream themselves back to the time when the margrave established his gallery: Le Prince completed the picture in 1774, just a few years later. ELISABETH HIPP

Aschaffenburg
State Gallery in Johannisburg Palace

Schlossplatz 4, 63739 Aschaffenburg | T +49 (0)6021 386570 | Disabled-friendly access |
www.pinakothek.de/staatsgalerie-aschaffenburg | Due to reopen in 2018

A whole universe of princely collecting unfolds in the rooms of Johannisburg Palace, majestically overlooking the River Main. Here, from the splendour of Early German Masters and intimacy of Dutch painting via the fascination of French and Italian Baroque to the expressiveness of eighteenth-century German vedute, the history of the Mainz electorate is palpable.

Standing before the palace, with their gaze directed towards Georg Ridinger's imposing building begun in 1605, visitors inevitably sense their next steps will transport them into an age in which religious and political forces changed the map not just of Germany but the whole of Europe. In the same way the architecture of Johannisburg Palace alternates between the Mannerist exterior and Neo-Classical interior, so the names of the great cities of Halle and Mainz resonate in the Aschaffenburg collection.

In addition to the emblem of the wheel on the corbels above the palace windows, the eyes of today's beholder will notice this most readily in a particular face. It is one already familiar to them from Matthias Grünewald's depictions of Saints Erasmus and Mauritius or from Lucas Cranach's 'Cardinal Albrecht of Brandenburg before the Crucified Christ' in the Alte Pinakothek. In Aschaffenburg this head with the striking facial features of a very long nose and deep wrinkles above the corners of the mouth appears on the wings of the Pfirtsch Altar and the panel painting depicting the 'Mass of St Gregory'. It is presented facing away from the miraculous manifestation of Christ on the altar. Unlike the other clergy in their richly decorated canonicals, Albrecht of Brandenburg does not need to see the wan flesh of the Son of God in order to understand His Passion.

In real life, too, Albrecht of Brandenburg's belief in God was so profound that not even Martin Luther's harsh denunciations could stop him from continuing to praise the Lord with the costliest of relics, the most precious liturgical utensils and outstandingly beautiful works of art. Under pressure from the Reformation the cardinal with the two powerful archbishoprics of Magdeburg and Mainz had to abandon the idea of a collegiate church as a *gesamtkunstwerk* for Halle. Nevertheless, he was determined not to leave behind his

Anonymous Master (Workshop of Lucas Cranach the Elder), The Mass of St Gregory with Cardinal Albrecht of Brandenburg, 1520/25 (detail) | Inv. No. 6270

extraordinary collection, and so took at least parts of it with him when he went into exile in Aschaffenburg.

Splendid works of Early German painting by such illustrious names as Grünewald or Hans Baldung Grien and, above all, Lucas Cranach the Elder and his workshop found a new home in the Ottonian basilica – and presumably also in the building that had previously occupied the site of Schloss Johannisburg. For since the time of the great Willigis, who skilfully guided his archbishopric through the early Middle Ages, the ecclesiastical princes of Mainz had used Aschaffenburg as their second residence.

Two hundred years after Albrecht of Brandenburg, the palace again became a place of refuge for an archbishop of Mainz: the Elector Friedrich Carl Joseph von Erthal, who can still be seen here in a portrait clothed in a bright red cloak with ermine trimmings. Apart from the library, furniture and his own skin, Erthal managed to save 260 of his paintings after the French occupied Mainz. One gains some idea of the splendour of the electoral gallery in Mainz by strolling along the rows of Baroque paintings from all over Europe now on display in Aschaffenburg. Views of towns and cities along the Rhine and Main by the court artists Christian Georg Schüz, Ferdinand Kobell and his son, Wilhelm, document the territory over which the prince-archbishops held sway.

In an age when the idea of a public museum was gradually taking shape, it was the last of the Mainz electors who drew all the threads together. In 1803,

Abraham Bloemaert, The Preaching of St John the Baptist, c. 1620 | Inv. No. 2045
Hans Baldung, called Grien, Calvary, c. 1533/36 | Inv. No. 6277

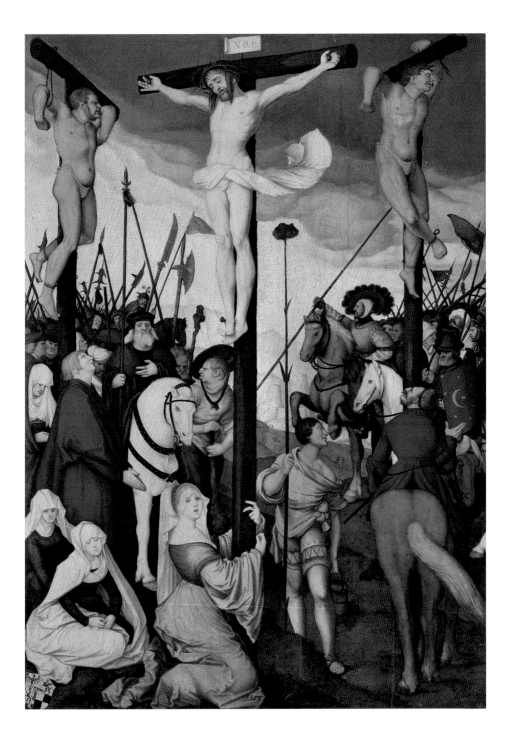

after the temporal jurisdictions of the clergy were abolished and church lands taken over by the state, Archbishop Carl Theodor von Dalberg brought to Johannisburg Palace not only Aert de Gelder's Passion cycle together with other parts of the collection belonging to his uncle, the cathedral provost Hugo Franz von Eltz. With the keen eye of a connoisseur and a far-sightedness unusual among collectors in the early nineteenth century, he also had masterpieces of Early German art once owned by Albrecht of Brandenburg transferred from the collegiate church to the palace, where they were united with Erthal's legacy to form the core of the Aschaffenburg collection.

In 1814, the gallery passed into the ownership of the kingdom of Bavaria, under whose auspices it was reorganized a few years later by Johann Georg von Dillis. When Johannisburg Palace was finally restored in 1964, the State Gallery there reopened with a strong focus on its history as a Cranach centre.

Today's visitors to Aschaffenburg can explore artworks through a 'school of seeing' on many levels. The enfilades of rooms on the first and second floors of the palace not only lead the viewer through centuries, regions and genres, but also present the collecting habits and constantly changing balances of power in Europe reaching well into the nineteenth century. At the centre of the collection are the radiant paintings of Lucas Cranach and his artists. With a treasury of motifs that served both Catholics and Reformers, his workshop succeeded in chipping away at the hardened fronts between the religious denominations. If we retrace the path from the palace back to the original home of the Cranach pictures in the collegiate church, then in the neighbouring museum we will encounter the magnificent Magdalene Altar, whose various components had been scattered abroad over the centuries and in 2009 were finally reassembled here in all their glory. NADINE ENGEL

Augsburg
State Gallery in St Catharine's Church

Maximilianstrasse 46, 86150 Augsburg, entrance Schaezlerpalais | T +49 (0)821 510350 | Open daily except Mondays | www.pinakothek.de/staatsgalerie-katharinenkirche

The State Gallery is somewhat hidden away. Visitors need to enter the Schaezler-palais via the entrance on Maximilianstrasse, walk through the long enfilade of rooms in the Baroque Gallery and cross the breathtaking ballroom (where Marie Antoinette is known to have danced in 1770 following her betrothal to the king of France) in order to reach the former St Catharine's church – a journey back in time to the start of the sixteenth century.

After some delay the church of the dissolved convent of St Catharine was inaugurated as a branch gallery on 12 October 1835 – to a fanfare of trumpets and cries of 'Long live the king!' King Maximilian I of Bavaria had designated the building for this purpose as early as 1807, but at that time there was no money to implement the plan. From 1810 onwards, a passable temporary venue was found in the town hall, an arrangement that lasted till the church could finally be converted into a gallery in 1833. The floor was raised to the level of the 'nuns' gallery', while partition walls provided space for hanging artworks. And so the church of the Dominican nuns became one of the most atmospheric branch galleries of the Bavarian State Painting Collections. The temporal closeness and geographical proximity between the building and its pictures and their original location is tangible. The last room in particular has retained the original decor of the church, which was consecrated in 1517. It is one of the earliest interiors of the Renaissance style.

Great names are associated with the convent, names that bring the history of Augsburg to life: Fugger, Welser, Riedler, Walther, Vetter, Rehlinger ... The affluent patricians and merchants of the city were more than happy to entrust their daughters to the convent of St Catharine, and they brought with them not only rich dowries, but also the refined artistic taste of a cosmopolitan upper class. The high standard of Augsburg art at the turn of the sixteenth century was comparable only to that of Cologne or Nuremberg, and can be largely explained by the demands of a spoilt clientele, and so the convent of St Catharine was probably one of the most richly decorated of all the city's monastic institutions.

It had to be none other than Hans Holbein the Elder and Hans Burgkmair to provide the paintings for the chapter house of the convent when rebuilding

Hans Burgkmair the Elder, All Saints Altar: Mary and Christ Enthroned, 1507 (detail) | Inv. No. 5325

started in 1499. The cycle of pictures that resulted, showing the seven main churches in Rome – an unusual theme that demanded the undivided creative powers of the artists – is one of the outstanding achievements of German painting at this time. Today, the panels with their pointed arches constitute the focus of the gallery, just a few yards from the site for which they were originally intended. But did this splendour match the strict rules of a mendicant order? No problem, contemporaries would have replied. After all, the paintings were not private property, but belonged to the convent and so were in the service of the greater glory of God.

Holbein's epitaphs for the Walther family and Dominican Vetter sisters, his paintings for the wings of the retable of the altar dedicated to the convent's patron saint, and the colourful All Saints Altar by Hans Burgkmair all come from St Catharine's church, as do the somewhat old-fashioned-looking paintings by Thoman Burgkmair, Hans's father. With the dissolution of the monasteries, the convent's paintings became public property – in the hands first of the imperial city, then of the kingdom of Bavaria. The branch gallery provided an ideal opportunity to leave the paintings in their original place.

No less splendid are the paintings from the Dominican church of St Mary Magdalene, just a stone's throw from the convent. Like St Catharine's, it was designed by the architect Hans Hieber as a double-nave structure. In 1517, the workshop of Ulrich Apt painted numerous portraits of the donor family on the Rehlinger Altarpiece. The monstrous fantasy creatures that swarm around the cross of the wicked thief on this retable are unique in the painting of that period. The depictions that come closest to them, if at all, are to be found in the work of Hieronymus Bosch. In around 1520 Leonhard Beck painted the Magi picture of the von Stetten family. His workshop was also responsible for the wing paintings with which Jakob Fugger 'the Rich' closed off the marble retable in his chapel in the Dominican church.

We know a great deal about the gallery's artworks, their donors, their creators and the nearby places for which they were destined. This, together with the high quality, is a further distinctive feature of Augsburg painting around 1500. By contrast, nothing remains of Augsburg's huge winged altarpieces of the late Middle Ages and early Renaissance. Maybe they never even existed. Evidently Augsburg boasted less with size but instead with quality, with the realism of the portraits, the unusual themes of the pictures, the costliness and rarity of the materials depicted, and the careful execution. The panels of the Wettenhausen Altarpiece by Martin Schaffner from Ulm, on display in the final room of the gallery, and those of the Christgarten Altarpiece by Hans Schäufelein from Nördlingen provide examples of these impressive liturgical items.

Hans Holbein the Elder, The Coronation of the Virgin, 1499 | Inv. No. 5335

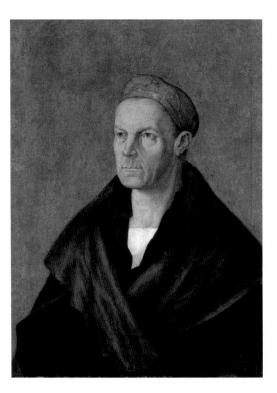

Albrecht Dürer, Portrait of Jakob Fugger 'the Rich', c.1520 | Inv. No. 717
Lucas Cranach the Elder, Samson and Delilah, 1529 (detail) | Loan from the Collections and Museums of Augsburg

The State Gallery conveys the image of late fifteenth- and early sixteenth-century man (from 1490 to around 1540) not only in role or donor portraits. There is also a stand-alone portrait of the supreme ruler and frequent guest to the imperial city, Emperor Maximilian himself. Further figures to be seen are the bishop of Augsburg and builder of the Hohes Schloss in Füssen, Friedrich von Zollern, as well as the Strasbourg preacher Johannes Geiler von Kaysers-berg, the imperial chancellor and friend of the bishop. Impressive monuments to citizens and learned men of the imperial city were created by that master of his art, Christoph Amberger, with portraits of the goldsmith Thoman Peyrl, the furrier and trader Wilhelm Merz, and above all the humanist and jurist Conrad Peutinger and his wife. Peutinger's daughter Felicitas, incidentally, lived in St Catharine's convent until she left in 1531. The portrait of the city's most famous son, Jakob Fugger 'the Rich', was the preserve of the country's most famous artist – Albrecht Dürer from Nuremberg. MARTIN SCHAWE

Augsburg
State Gallery of Modern Art
in the Augsburg Glaspalast

Beim Glaspalast 1, 86153 Augsburg | T +49 (0)821 324 4155 | Open daily except Mondays | Disabled-friendly access | www.pinakothek.de/staatsgalerie-glaspalast

Since 2006, the Glaspalast in Augsburg has housed the branch gallery of the Pinakothek der Moderne. On an annually rotating basis, highlights of post-war art are displayed here – in an industrial palace dedicated to contemporary art.

It is not only the visual arts that attract visitors to this gallery but the architecture itself, for the building, which was completed in just nine months in Augsburg's 'textile quarter', is positively dematerialized by the extensive glazing. This determines the structure of the façade and gives the former spinning and weaving mill its name: Glass Palace.

Built by Philipp Jakob Manz in 1910, the Glaspalast is one of the earliest steel-framed buildings in Germany. Thanks to its architecture, it offers a fascinating alternative to the 'white cube' often favoured by museum galleries. And so here, the renewed encounter with works familiar from Munich becomes an intense experience.

The former textile factory, so elaborately restored with rooms flooded by natural light, is an ideal forum for the presentation of exhibitions. The 1,500-square-metre ground floor provides the space and opportunity to focus on the collection's various aspects of contemporary art – from German to international art, from Georg Baselitz to Andy Warhol. In doing so, the State Gallery of Modern Art in Augsburg acts as a 'laboratory' allowing for precise inspection of entire complexes of works, which would not be possible for so long on such a scale in the Pinakothek der Moderne. CORINNA THIEROLF

Installation view from the exhibition 'Jörg Immendorff. Versuch, Adler zu werden', 2006

Bamberg
State Gallery in the New Residenz

Domplatz 8, 96049 Bamberg | T +49 (0)951 519390 | Open daily | Disabled-friendly access | www.pinakothek.de/staatsgalerie-bamberg

Fifteenth-century painting of the Cologne School – that's not what one would automatically associate with Bamberg's Domberg. While the cathedral square (Domplatz), with the cathedral, the old episcopal palace (Alte Hofhaltung) and the new episcopal palace (New Residenz) constitutes in itself a *gesamtkunstwerk* – a total work of art – that has grown over the centuries, visitors to the city will also find a number of museums competing for the favour of art lovers. The State Gallery in the new episcopal palace is a valuable insider tip.

The State Gallery was established in 1933 in Bamberg's new episcopal palace with paintings from the collections of the city and the Bavarian state. Redesigned in 1968, it now consists of two departments situated in different wings on the first floor of the building – one being the Baroque Gallery in the so-called Cavaliers' Rooms created under Prince-Bishop Adam Friedrich von Seinsheim between 1771 and 1773, and the other the Early German Gallery in the oldest part of the complex, the 'Gebsattelbau', named after a contemporary, early seventeenth-century bishop.

Visitors first enter the Baroque Gallery. It was completely refurbished in 2013, with a new presentation of the paintings and the installation of an improved lighting system. The portraits on the entrance wall depict two prince-bishops who each left their mark on the interior and exterior of the palace: on the right Friedrich Karl von Schönborn-Buchheim, and on the left Adam Friedrich von Seinsheim. Among the fixtures along the enfilade of rooms that begins here are the supraportes with landscapes and allegories of the arts and sciences painted by the Bamberg artists Johann Christoph Treu and Marquard Treu, and probably Johann Kupetzky as well.

Additionally there are two large-scale gallery views by Johann Michael Bretschneider dating from the early eighteenth century. The arrangements of pictures in numerous rows according to size and symmetry are textbook examples of Baroque presentation practice; a colourful mixture of genre, school and date. The paintings on display were undoubtedly well known through reproduction prints, a medium which flourished in the seventeenth and eighteenth centuries.

Hans Baldung, called Grien, The Flood, 1516 (detail) | Loan from the City of Bamberg

In the adjoining cabinet room, the Fürstbischöfliches Kabinett, visitors encounter in real life what Bretschneider depicted as fiction. The 40 paintings hung in a number of rows on the two walls come exclusively from the former gallery of the palace, and after thorough restoration in Munich have now returned to Bamberg, in some cases in their original frames.

Next we have the rooms with Dutch still lifes and landscapes. Rembrandt's contemporary Jan Lievens also has a room devoted to him, as does Otto van Veen, the teacher of Peter Paul Rubens. His six-part 'Triumph of the Catholic Church' strikes precisely the right note in an episcopal palace. Wall-filling works by Gerard de Lairesse and Karel Dujardin, together with Jacob van Loo's 'Allegory of Fortune', mark the end of this section of the State Gallery, which, for connoisseurs and ordinary art lovers alike, has undergone a visible upgrade as a result of the high quality of the selection and a shift of emphasis towards international High Baroque.

It is just a short walk to the Early German Gallery. The glittering gold of the fifteenth-century paintings of the Cologne School radiates an atmosphere of ceremonious solemnity in the dimly lit rooms. The odour of polished floor is not out of place, and is in keeping with the patinated walls. Here, visitors might feel they are back in the Heidelberg of 1815, when Goethe saw these pic-

tures for the first time. A selection from the famous collection of the Boisserée brothers from Cologne is on display, and includes the first picture they acquired (in 1804), namely 'Christ Carrying the Cross' by the Master of the Lyversberg Passion. In 1827, King Ludwig bought the 216 Netherlandish and Cologne School paintings for the enormous sum of 240,000 guilders, a worthwhile investment as some of the works are now among the most famous in the Alte Pinakothek. But the king was embarrassed by the price and refused to allow it to be made public, thinking – no doubt correctly – that his subjects would not be happy about his spending this sort of money on art. Those wishing to see the entire Boisserée Collection must go not only to Munich and the Germanisches Nationalmuseum in Nuremberg, but also to Bamberg.

Next come works painted in Bamberg in the fifteenth century, including numerous loans from the city. The depiction of the appearance in Bamberg in around 1450 of the Italian preacher of repentance, Johannes Capistran, shows citizens against the late-medieval backdrop of the Domberg. They are portrayed full of remorse, consigning the evidence of their sinful ways – playing cards, dice, and fashionable knick-knacks – to the flames. The preaching had had its effect. Of high quality are the panels of the St Clare Altar from the Poor Clares' convent in the city, captivating by dint of their realistic detail and tangible Netherlandish influence. In particular, the 'Stigmatization of St Francis' would have been inconceivable without knowledge of the corresponding painting by Jan van Eyck. The Bamberg artists Wolfgang Katzheimer, Paul Lautensack and Hans Wolf are each represented with several works. With them, we move on into the sixteenth century.

Paintings from the age of Dürer form the culmination and conclusion of the chronological sequence in the gallery. Numerous works by the great colourist Hans von Kulmbach, a pupil of Dürer's, can be found here. The final room is devoted to Lucas Cranach the Elder and his circle. Hans Baldung Grien shows us with his depiction of 'The Flood' not only an uncommonly profound concept of the destruction of the world that consciously mixes apocalyptic motifs into the Old Testament story, but also an image of human despair and mortal fear, the like of which was seldom more convincingly portrayed in Early German painting. MARTIN SCHAWE

Master of the Heisterbach Altar, Crucifixion Altar, 1440s (detail) | Inv. No. WAF 503

Bayreuth
State Gallery in the New Palace

Ludwigstrasse 21, 95444 Bayreuth | T +49 (0)921 759690 | Open daily except Mondays | Disabled-friendly access | www.pinakothek.de/staatsgalerie-bayreuth

After Ansbach, Aschaffenburg, Bamberg and Würzburg, Bayreuth was the fifth city to open a branch gallery of the Bavarian State Painting Collections in Franconia. Some 80 works by Dutch and German painters dating from around 1700, and now on display in the renovated rooms of the margravial palace, bring the character of an eighteenth-century court gallery to life.

On the evening of 26 January 1753, a devastating fire broke out in the Old Palace in Bayreuth and destroyed most of the building. As the ponds were frozen over, it was difficult to find water to put the blaze out, and so the fire raged on for an entire week, rendering the building uninhabitable. As Margrave Friedrich of Brandenburg-Bayreuth had previously tried in vain to obtain funds to refurbish the dilapidated building, the urgent necessity to build a new palace for himself and his consort, Friederike Sophie Wilhelmine – a residence which would meet the heightened cultural and intellectual aspirations of the age – may well have been most opportune. That very same year, work began on building the New Palace on the grounds of the former racecourse. It was designed by the court architect Joseph Saint-Pierre and largely completed two years later. It is worth noting that the new complex incorporated a number of existing buildings. These are still in evidence today, as closer inspection of the both the exterior and interior reveals. And so the conversion of the structural work made way for the middle section of the new building with entrance, staircase and banquet hall.

Following the lead of Düsseldorf, Dresden, Kassel and Schleissheim, the margrave and his consort had a picture gallery installed in the garden apartments in the south wing of the palace. Although it is no longer possible to fully reconstruct the selection and arrangement of the paintings hung there, surviving inventories show that, in addition to artists from Franconia and other parts of southern Germany, Dutch and Flemish artists in particular were well represented with such prominent works as the panel, dated 1614, of 'Venus and Adonis' by Hendrick Goltzius, which today is one of the central works in the Dutch Room of the Alte Pinakothek in Munich.

Rachel Ruysch, Bouquet of Flowers, 1708 (detail) | Inv. No. 430

After the refurbishment of the New Palace and the re-creation of the lavishly restored picture gallery in 2007, Bayreuth now commands a strong historical presence with its fine ceiling plasterwork and elaborate wall hangings. On display in the three rooms of this branch gallery are some 80 works by Dutch and German painters dating from the late seventeenth century and well into the eighteenth century. The emphasis is on Dutch painting in the years between 1670 and 1730. Taking their cue from the French court, which set the tone in such matters, the painters of the late Golden Age pursued a cool, decorative elegance and an idealizing, formal vocabulary oriented towards classical models. Many of the exhibited works come from the estate of the Wittelsbach Elector Palatine, Johann Wilhelm of Palatinate-Neuburg, who, to supplement his already famous collection, engaged leading Dutch artists at his court. The focus of the Bayreuth gallery has always been on scholarly history painting, which in those days ranked above all other genres. Compositions with numerous figures portray episodes from Greek and Roman history and mythology. Visitors to the gallery will encounter the divine Venus and Bacchus, the lovers Dido and Aeneas, the bold and wily adventurer Odysseus, the heroes Achilles and Perseus, and not least the Egyptian royal beauty Cleopatra and a triumphant Alexander the Great. The highlights of the gallery include history paintings by Adriaen van der Werff, Gerard de Lairesse and Gerard Hoet, splendid floral still lifes by Rachel Ruysch and Jan van Huysum, along with depictions of dead game by Jan Weenix. In order to bring to life the character of an eighteenth-century gallery, the paintings are presented close together in

two rows and mounted in richly decorated gilt Rococo frames. On display in the adjoining decagonal room, the former 'Salet' with access to the garden, are eighteenth-century German, Dutch and Flemish landscapes influenced by the Dutch Golden Age. Beyond this room is a small cabinet presenting a selection of portraits, genre scenes and still lifes by the Munich-based Flemish court painter Peter Jakob Horemans, whose detailed works convey the culture of the eighteenth century in all its facets – taking the viewer on a journey through time into the everyday world of south German Rococo.

The interplay of landscape and architecture, interior and exterior following the example of nature still, which was so characteristic of the concept the margrave couple Friedrich and Wilhelmine planned for the palace, has the capacity to surprise large numbers of enthusiastic visitors. In the rooms of the State Gallery in the New Palace they can enjoy paintings of the late Baroque period – one that was held in such high regard throughout European courts of the eighteenth century. BERND EBERT

Burghausen
State Gallery in Burghausen Castle

Burg 48, 84489 Burghausen | T +(0)49 8677 4659 | Open daily |
www.pinakothek.de/staatsgalerie-burghausen

It's more than a thousand steps to our destination. The defensive complex, erected by the dukes of Lower Bavaria between the thirteenth and early sixteenth centuries on the ridge between the River Salzach and Lake Wöhr, needs to be explored on foot. And those visitors who take the trouble will be richly rewarded. On their way to the keep, across five forecourts, past the residential quarters, the fortified, administrative and utility buildings, they will gain a picture of life in times gone by.

Not one but several museums are located in the keep. The State Gallery in Burghausen was established on the first and second floors in the residential quarters in 1897, making it one of the most recent of the branch galleries of the Bavarian State Painting Collections. It is famous far and wide for late-medieval painting from Bavaria and the Austrian border region. Artworks that bear witness to the heyday of important Bavarian abbeys and convents – Tegernsee, Attel, Rottenbuch, to name but a few – are on display here. Without exception only fragments have survived the centuries, thus offering no more than a distant echo of the winged altarpieces, which originally were often six to seven metres wide and with their crest, almost as tall. With the dissolution of the monasteries in 1803, these artworks and other possessions passed to the state.

In reality, medieval features had often disappeared much earlier, with the wealthy monasteries of southern Germany in particular treating themselves to regular refurbishments. Consequently, numerous late-medieval altars were no longer in use by the turn of the nineteenth century, having been dismantled, placed aside or scattered to the four winds. Quite a few were destroyed. The dissolution saw to the rest, but at least it ensured that what survived ended up in the safety of museums. And so one must be grateful for every panel that was preserved. The numerous sculptures in the gallery, most of them on loan from the Bayerisches Nationalmuseum, serve as a reminder that the sculptural artwork on the retables has in many cases also been lost for ever.

The four panels in the first room testify to a particularly serious loss. They are all that remain of the original total of 14 winged altarpieces painted by the Munich artist Gabriel Mäleskircher between 1473 and 1479 for the Benedictine

Bavarian (?) Master, Portrait of Hans Hofer, c. 1485 | Inv. No. 12422

Bavarian Master (Master of the Attel Altar), Attel Altar: Feast of Herod with the Beheading of St John the Baptist, c. 1480/90 (detail) | Inv. No. 1405

monastery of Tegernsee. Mäleskircher is one of the few artists of his time known to us by name: a magnificent storyteller with an eye for detail, whose pictures can be understood without the need for many words, appealing as they do to human sentiments. Take the episode depicting the visit of the founder of the order, St Benedict, to his sister, Scholastica. When he signals his departure she secretly prays for him to stay. A violent storm ensues, and so the two are able to spend the whole night in pious conversation. It is a quiet, meditative image of sibling affection. Mäleskircher was versatile, as his picture of the temptations of St Vitus illustrates. It portrays noisy behaviour at court as the saint's pagan father seeks in vain to divert him from a virtuous life by exposing him to music, dancing, games and beautiful women – an event from the legend of the young saint, who was very popular in southern Germany.

The few portraits in the Burghausen gallery are characteristic examples of fifteenth-century portraiture. The likeness of Hans Hofer from Salzburg, painted by a Bavarian artist around 1485, testifies to the pride and prosperity of a medieval burgher. It shows the sitter, aged 30, with striking features and a white rose in his hand – a bridegroom of a relatively advanced age. Hans Hofer's family owed their wealth to the silver and copper mines of Tyrol. Hans's

father, Virgil, distinguished himself as one of the donors of the high altar in the Franciscan church in Salzburg, which was executed by Michael Pacher. By contrast, the portrait dating from around 1480–1496 of Duke Sigismund of Tyrol, known as the 'Münzreicher' ('Rich in Coins'), presents the sitter more as a burgher than ruler, with decidedly ascetic, albeit not unfriendly features, as though he were content with his life: after ruling for 44 years he abdicated in 1490 in favour of his brother Maximilian, the future emperor.

For what is the longest castle, only the largest pictures are good enough. The six monumental history paintings on the third floor of the keep are part of a ten-part cycle painted by the court artist Hans Werl between 1601 and 1603 for the Alter Herkulessaal in the ducal palace in Munich. They depict major events, mostly of a bellicose nature, from the history of the House of Wittelsbach, undoubtedly the most powerful being the Battle of Mühldorf, just 30 kilometres to the west of Burghausen. The central motif of the painting, which is almost eleven metres across, is the duel between the splendidly armoured Habsburg, Frederick the Handsome, and, on the Bavarian side, Albrecht Rindsmaul, who is recognizable by the 'canting arms' on his horse's caparison – his name 'Rindsmaul' meaning 'cow's mouth'. The white horse of the Austrian standard-bearer collapsing before him signals the defeat of the Habsburg on 28 September 1322.

Further paintings, including copies made around 1600 of works by Albrecht Dürer, round off the picture of courtly art on display on the third floor of the State Gallery. The roof of the building is accessible to the public, and offers a magnificent view of the surrounding countryside across the Austrian border, some 120 kilometres to the east of Munich. This, together with the gallery, certainly makes up for the long walk. MARTIN SCHAWE

Bavarian Master, Flight into Egypt, c. 1500 | Inv. No. 2618

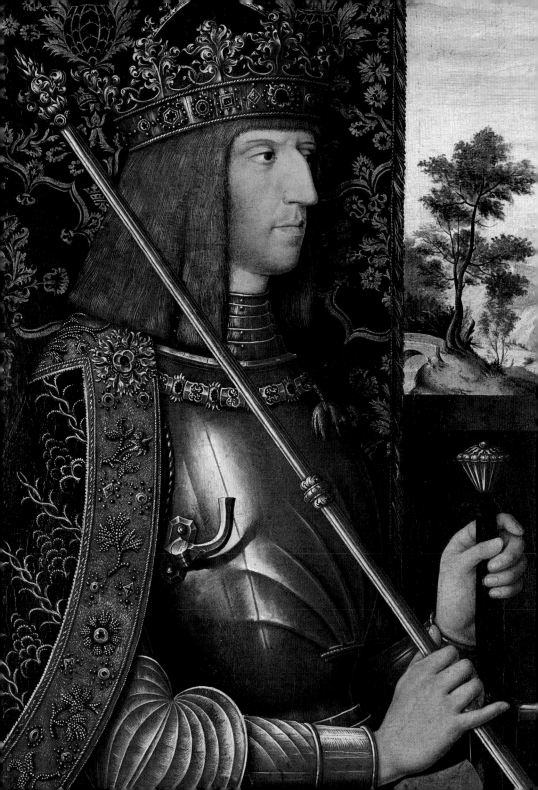

Füssen
State Gallery in the Hohes Schloss

Magnusplatz 10, 87622 Füssen | T +49 (0)8362 903 164 /-145 | 1 Apr to 31 Oct: Open daily except Mondays; 1 Nov to 31 Mar: Open Fridays to Sundays | www.pinakothek.de/staatsgalerie-fuessen

Even the Romans appreciated the site on the hill next to the Via Claudia Augusta, and built a fort here. In the High Middle Ages it was replaced by a castle that eventually took on its present shape between 1490 and 1503 thanks to Prince-Bishop Friedrich II of Hohenzollern, an enthusiastic builder. The State Gallery is on the second floor of the north wing.

Like most of the branch galleries, the one in Füssen exhibits works with a regional association, in this case Swabian and Alpine art of the late-medieval period. The focus is on painting, and includes in the interior courtyard the unusual (albeit frequently restored) illusionist façade dating from around 1500. Here, visitors should linger a while to take in the atmosphere and setting before entering the gallery itself.

In 1977, with the help of loans from the Bayerisches Nationalmuseum in Munich, it was possible to upgrade the State Gallery. Fifty-nine sculptures and paintings are now on display in Füssen. Many centuries have set their mark on the interior rooms. The most authentic is probably the grand Knights' Hall with its beautifully carved wooden ceiling dating from the turn of the sixteenth century. The image fields depict the Madonna and Child along with half-length figures of the patron saints of the bishopric of Augsburg (Ulrich, Afra and Simpert) and other bishops. The remains of original stained glass with coat of arms have been incorporated into the windows and show hunting scenes and allegories of the Virtues dating from between 1504 and 1520/30. In this room, not one but three works immediately catch the visitor's eye: the high-quality figures of John the Baptist and Mary Magdalene – the work of Jörg Lederer from Kaufbeuren around 1510 – and the larger-than-life-size portrayal of 'Christ as Salvator Mundi' dating from 1494. This panel once had a counterpart depicting the Virgin Mary, but it is now lost. Both the panels were commissioned by Friedrich of Hohenzollern, who had the castle built. However, they were not painted for the castle, but brought to Füssen in the seventeenth century from the Abbey of Ulrich and Afra in Augsburg.

We can thus say with some certainty that this painting of Christ the Saviour came from a workshop of Augsburg painters. Augsburg, Ulm, Memmingen,

Bernhard Strigel (copy after), Emperor Maximilian I, 17th century (detail) | Inv. No. 1156

137

as well as Kaufbeuren and Nördlingen – Swabian painting was an art of centres, mostly free imperial cities, that brought forth outstanding artists: painters and sculptors alike. These were the workplaces of Hans Holbein and his studio, Bartholomäus Zeitblom and Bernhard Strigel, who are represented with several works in this gallery.

It was Zeitblom who created the panels, now mounted one above the other, with the tender figures of St Anthony the Hermit and an unidentifiable knight-saint, as well as (in the last room) parts of a large sacramental altarpiece from the Augustinian priory 'zu den Wengen' in Ulm. From the workshop of Hans Holbein the Elder the gallery has on display the altarpiece wings, dating from after 1505, that depict scenes from the legend of the saintly imperial couple Heinrich and Kunigunde. It was presumably Duke Albrecht IV of Bavaria and his consort, Kunigunde, who donated these works.

Also from Holbein's circle (on the window side) are the wings of an altarpiece from the Cistercian nunnery of Oberschönenfeld near Augsburg. These were executed by a pupil who could not achieve the precision or sense of colour of the master. Also noteworthy is the well-preserved retable of the Holy Kin-

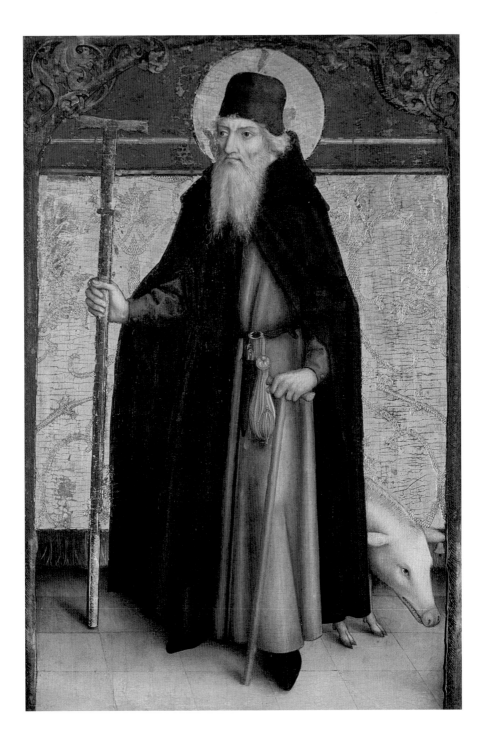

ship, painted in the Allgäu in around 1520. It brings out well the functional association between the shrine, the fixed wings and the predella. Evidently this altarpiece did not have hinged wings.

The second room in the gallery took on its present form, with a squat, columned portal, in the late seventeenth century under Bishop Johann Christoph von Freyberg. In keeping with the individual design of the room, the paintings shown here all have a local connexion. The 16 scenes from the legend of St Magnus were painted in honour of the founder of the Abbey of St Mang. A Scottish prince, he preached the gospel as an itinerant monk in the Allgäu from 746 on. The epitaph to the founders of Steingaden Abbey, 20 kilometres to the north-west of Füssen, commemorates a further monastic foundation.

Secular depictions from the late Middle Ages have survived to a far lesser extent than religious works of art – all the more reason, then, to appreciate the two works 'Plague' and 'War' dating from around 1510 and on show here. The anonymous artist definitely knew what he was painting. The arrows symbolizing the Black Death point precisely to those parts of the body where the swelling of the lymph nodes appeared. In the depiction of 'War', too, the details are realistic: peasants are portrayed advancing against an aristocratic cavalry. The decorative appeal of the close-up figures in their silvery armour immediately captivates the beholder. Certainly the overarching theme was that of divine punishment as understood in the Old Testament. The third picture in the cycle was 'Hunger'. Had it survived, it would make for an interesting exhibit.

Numerous other paintings from the fifteenth and early sixteenth centuries await visitors to the gallery. They bring to life the history of the place and the region. On display are the panels from the high altar of St Mang, painted around 1460/65 by a master from Ulm, and the copy of a work now lost by Bernhard Strigel – a portrait of Emperor Maximilian I, a frequent and welcome guest to the castle. MARTIN SCHAWE

Upper Swabian Master, The War, c. 1510 (detail) | Inv. No. WAF 740

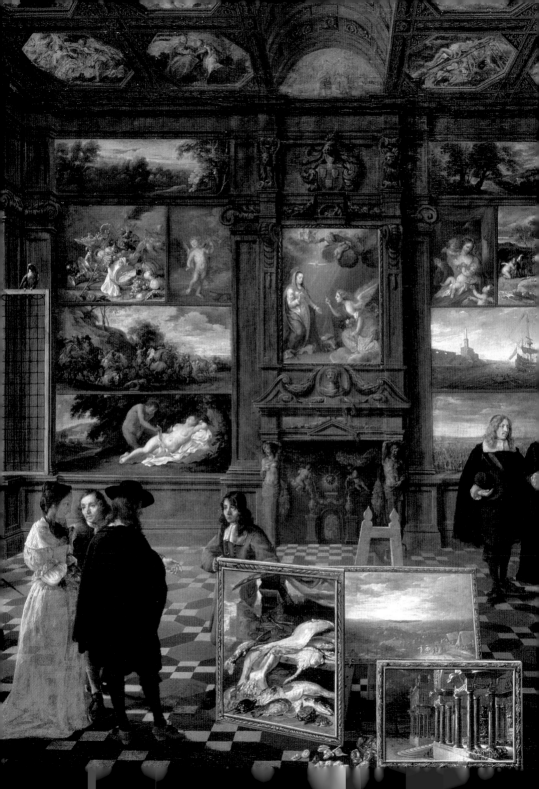

Neuburg an der Donau
State Gallery in Neuburg Palace

Residenzstrasse 2, 86633 Neuburg an der Donau | T +49 (0)8431 64430 |
Open daily except Mondays | www.pinakothek.de/staatsgalerie-neuburg

An imposing palace, the first sacred building to be built as a Protestant place of worship in Germany, a town that has suffered no destruction, one in which the age of the Renaissance and Baroque lives on – all this provides the setting for the gallery in Neuburg an der Donau. It is the only one of the branch galleries to be devoted exclusively to Flemish Baroque painting. And here this can be experienced in a uniquely concentrated form. Exhibited in historic rooms are masterpieces by Peter Paul Rubens, Anthony van Dyck and Jacob Jordaens, along with delicately painted cabinet pictures by such masters of this art form as Jan Brueghel the Elder, Frans Francken the Younger and David Teniers the Younger.

The State Gallery in Neuburg is one of the more recent branch galleries of the Bavarian State Painting Collections. Developed on an historic site, it opened to the public in 2005 to coincide with the quincentenary celebrations of the Duchy of Palatinate-Neuburg. In 1619, Rubens was commissioned to paint two altarpieces for the court chapel in Neuburg: one depicting the 'Adoration of the Shepherds' and the other, 'The Descent of the Holy Spirit'. Originally they flanked the main altarpiece, the 'Great Last Judgement' (today in the Alte Pinakothek), but now they constitute the highlight of the gallery in Neuburg. Why did Rubens create this splendid ensemble for what was, after all, a minor German court compared with those of the Great Powers? The answer lies in the interplay of regional and European interests. In 1613, having converted to Roman Catholicism, Count Palatine Wolfgang Wilhelm became the ally of the governor of the Spanish Netherlands, whose court painter was none other than Peter Paul Rubens. Today, Wolfgang Wilhelm is represented in the gallery in a portrait by Anthony van Dyck and his workshop.

History also comes to life in the exhibition rooms. The State Gallery was installed in the splendid west wing of the Neuburg Palace, which, starting in 1537, Count Palatine Ottheinrich had built as part of the conversion of the building from a medieval castle to a Renaissance-style palace with four wings. The façades of the inner courtyard display Italian influence with their arcades and sgraffiti decoration (pictures created with a scratching technique used to uncover coloured plaster). Some of the interior decoration has remained to

Wilhelm Schubert van Ehrenberg et al., View of a Picture Gallery, 1666 (detail) | Inv. No. 896

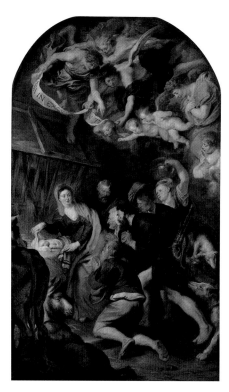

this day in the form of coffered ceilings, coloured stone floors and stone window frames, all of which bear witness to the richness of the original spatial effect. This culminates in the main hall on the second floor, where a monumental barrel-vaulted ceiling covers the entire storey. To mark the re-establishment of the gallery a ceiling was put in place whose shape was conceived to recall this masterpiece – unfortunately lost in the nineteenth century – of German Renaissance architecture.

Lavish collections were all part of courtly display. The dense hanging of the paintings on display today in what were once the smaller private apartments is historically accurate. The painting 'View of a Picture Gallery' (1666) by Wilhelm Schubert van Ehrenberg in collaboration with other Antwerp painters illustrates how such a presentation must have looked in those days. It shows an ideal gallery room with pictures hung so closely that they cover the wall like a tapestry. This showpiece demonstrating the artistic capabilities of the St Luke's Guild in Antwerp is directly related to the collection concept of the State Gallery.

The extraordinarily high quality and variety of Flemish painting is evidenced not only in the works of truly significant painters such as Rubens, van Dyck and Jordaens, but also in the many genres on display: still life, landscape and genre alongside history, allegory and portrait painting – all represented by outstanding examples. The 1616 cycle of the 'Four Seasons' brought together two highly specialized painters – Jan Brueghel the Elder, who painted the landscapes and details with fine brush strokes, and Hendrik van Balen, who added the figures. They embody the four seasons, whose characteristic qualities are illustrated by attributes such as fruit, flowers, animals and seasonal activities such as the harvest or the hunt – all painted with deceptive realism. The 'Cats' Concert' by David Teniers the Younger presents a charming example of genre painting. His musical felines are depicted creating a cacoph-

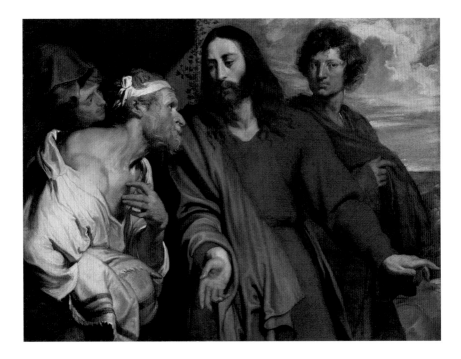

Anthony van Dyck. The Healing of the Paralytic, n.d. | Inv. No. 559
Next double page: Jan Brueghel the Elder and Hendrik van Balen, Spring, 1616 (detail) | Inv. No. 13709

onous 'caterwauling', thus symbolizing the human being, who, as the fatuous fool embodied by a colourfully dressed monkey, refuses to recognize the limits of his own talent.

In addition to the Rubens altarpieces cited above, visitors' attention will also be drawn to some early works by Anthony van Dyck: for example, 'The Healing of the Paralytic' and five 'Head Studies'. Van Dyck's actual specialism, portraiture, is represented by his 'Iconography', a series of portrait engravings of leading personalities of his day. Here in Neuburg are some of the grisailles on which they were based. The 'Self-Portrait' by Jacob Jordaens reflects the social ambitions of the seventeenth-century artist. It shows the painter with neither brush nor palette in his hand, but instead holding a scroll – in the mode of a scholar. With this presentation of himself as a cultured patrician, Jordaens, like Rubens and van Dyck, symbolizes the age of the Baroque painter-prince, an age brought to life in a particularly singular way in the State Gallery in Neuburg. MIRJAM NEUMEISTER

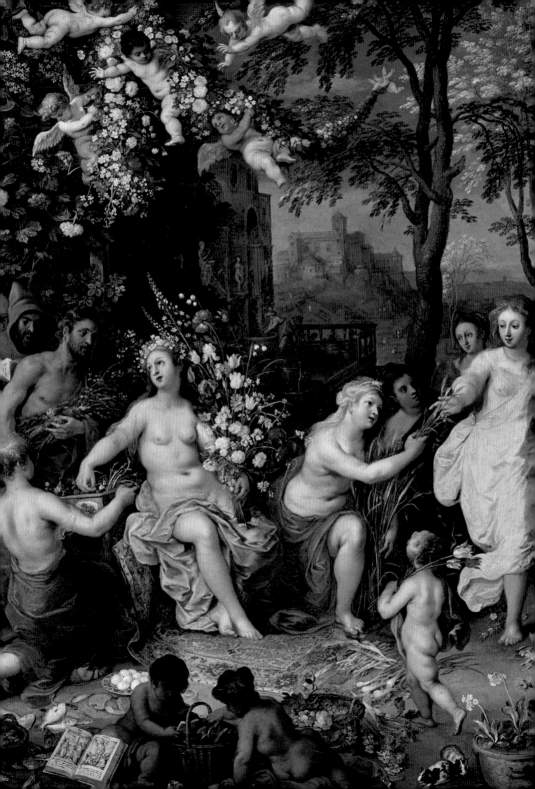

Oberschleissheim
State Gallery in the New Palace in Schleissheim

Max-Emanuel-Platz 1, 85765 Oberschleissheim | T +49 (0)89 3158720 | Open daily except Mondays | www.pinakothek.de/staatsgalerie-schleissheim

Well over 200 seventeenth- and eighteenth-century paintings, including master-pieces by Luca Giordano, Peter Paul Rubens, Joachim von Sandrart and Nicolas Poussin, make a tour of what is one of the most attractive Baroque palaces an unusual experience. For almost nowhere else do we find such striking examples of how pictures in royal residences under the *ancien régime* served the purpose of princely self-presentation.

Situated not far from Munich, the State Gallery in the New Palace in Schleissheim complements at the highest level the artworks on display at the Alte Pinakothek. The abundance and quality of the European Baroque paintings that adorn the entire palace lend this branch gallery a particular status. The setting is magnificent. It is located in a palatial building designed by Henrico Zuccalli, construction of which began in 1701. It was completed in 1719 under the auspices of the court architect Joseph Effner and was furbished with rich interior decoration by such renowned artists as Johann Baptist Zimmermann, Cosmas Damian Asam and Jacopo Amigoni.

The New Palace, commissioned by the politically ambitious Elector Maximilian Emanuel of Bavaria, who reigned until 1726, became an important place for displaying the Wittelsbachs' treasury of pictures once construction was provisionally completed. Through extensive purchases of large quantities of items, Maximilian Emanuel was able to extend his ancestral collection by more than 1,000 works. In doing so, the elector undoubtedly had in mind artistic decoration that would be commensurate with his generously proportioned new palace. In accordance with family tradition and the example of the French royal court, he understood the practice of collecting and exhibiting art to be an intrinsic part of his duty of self-presentation as befitted his status. Accordingly, from the very beginning of the preliminary planning stage, Maximilian Emanuel placed the picture gallery right at the centre of the building. The Grande Galerie, more than 57 metres in length and based on the example of the Hall of Mirrors at Versailles, served as a connecting tract between the

Peter Paul Rubens, The Reconciliation of Esau and Jacob, n.d. (detail) | Inv. No. 1302

Luca Giordano, The Death of Seneca, n.d. | Inv. No. 516

apartments of the elector and electress, thereby forming the setting for courtly ceremonial.

Following restoration and refurbishment in 2001, the Grande Galerie once again reflects its pristine appearance. The dark red, silk-damask wall hangings, against which the Flemish and Italian paintings are presented in the light coming through the eleven lofty French windows, were reconstructed on the basis of fragments recovered from the initial decoration. Original and contemporary gilt frames recall the uniform framing of the pictures as carved by Adam Pichler to designs by Effner. The earliest surviving inventory of paintings in Schleissheim, dating from 1748, lists 67 works for the Grande Galerie. Even then, apart from a few sixteenth-century Venetian paintings such as Titian's 'Christ Crowned with Thorns', the pictures in the gallery were almost all masterpieces of the Baroque period. The majority of them, including

Nicolas Poussin, The Adoration of the Shepherds, c. 1650/57 | Inv. No. 617

Rubens's 'Hunting Hippopotamus and Crocodile' and Guido Reni's 'Apollo Flaying Marsyas', are now in the Alte Pinakothek.

The current presentation in the south half of the Grande Galerie and adjoining electoral apartments shows exclusively works of the Flemish Baroque, in particular by Peter Paul Rubens and his assistants Anthony van Dyck and Jan Boeckhorst. These were acquired either by Maximilian Emanuel while governor of the Spanish Netherlands in Brussels, or by his cousin Johann Wilhelm for his gallery in Düsseldorf. Four of the famous gallery pictures by David Teniers the Younger document the original appearance of the gallery and the cabinet of curiosities of the Austrian governor of the Spanish Netherlands, Archduke Leopold Wilhelm. They are on view along with small-format scenes of peasant interiors by the same artist in the Flemish Cabinet, which originally held 162 pictures.

In the north half of the Grande Galerie and the apartments of the electress, visitors can experience a fascinating panorama of Italian Baroque painting. Chronologically the sequence starts with Ludovico Carracci and later works of Guercino as representatives of the classicizing tendencies in Bologna. Two monumental altarpieces, executed by Carlo Saraceni and Marcantonio Bassetti on behalf of Elector Maximilian I for the Augustinian Church in Munich,

Joseph Vivien, Allegory on Elector Max Emanuel and His Family Reunited, 1733 | Inv. No. 2477

Joachim von Sandrart, Allegory of November, 1643 (detail) | Inv. No. 366

provide examples of how closely the masters active in Venice studied the innovations of their fellow artists in Bologna and Rome. Luca Giordano's history painting of the dramatic death of Seneca, a virtuoso depiction in sharp chiaroscuro, represents the Neapolitan School of painting upon which Giuseppe de Ribera had left his mark. The ubiquitous Caravaggisti are represented by Bartolomeo Manfredi's 'Christ Crowned with Thorns', and the success of Florentine Baroque painting is particularly apparent in a Madonna by Carlo Dolci.

In the north part of the ground floor, Joachim von Sandrart's series of lifelike allegories of the months provides a powerful focus for the extensive selection of German painting. This cycle, created in 1642/43 for the Old Palace in Schleissheim, was transferred to the New Palace, where it came to adorn the Audience Chamber of Prince Karl Albrecht. His apartments to the left of the Garden Room are now dedicated to French painting. Works closely associated with Maximilian Emanuel, in particular the portraits by his court painter Joseph Vivien and not least the latter's principal work, the 'Allegory on Elector Max Emanuel and His Family Reunited', are bound to attract attention, as do three religious history paintings by Nicolas Poussin. ANDREAS SCHUMACHER

Ottobeuren
State Gallery in the Benedictine Abbey

Sebastian-Kneipp-Strasse 1, 87724 Ottobeuren | T +49 (0)8332 7980 | Open daily from Palm Sunday to the end of October. Otherwise limited opening times | www.pinakothek.de/staatsgalerie-ottobeuren

One of the smallest of the branch galleries of the Bavarian State Painting Collections, housed in bright rooms beneath the Baroque ceilings of the former imperial abbey, is home to artworks which are exquisite yet far too little known. Here, late-Gothic panels and European Baroque painting convey some impression of the wealth of the former monastic gallery.

Tradition has it that the Benedictine Abbey of Ottobeuren was founded in 764. As early as the tenth century it was self-governing under the emperor. While subsequently the bailiwick rights were held by the prince-bishop of Augsburg, in 1710 its full imperial status was restored. The Baroque complex dating from between 1711 and 1766 reflects the worldly powers of the abbots. In the non-spiritual wing of the new monastery, Abbot Rupert Ness, very much in the spirit of princely palace building of the age, had a picture gallery installed. It assembled its exhibits from monastic collections but also purchased artworks and accepted donations. Abbot Honorat Göhl extended the collection considerably in the last third of the eighteenth century. When the abbey was dissolved in 1802/03, the paintings in the gallery passed into Bavarian state ownership. Many were auctioned off in the first half of the nineteenth century, thus greatly reducing the size of the collection. Those of superior quality retained in Munich were put on display as part of the celebrations of the abbey's 1200th anniversary in 1964. When this exhibition came to an end, they remained in the abbey, initially as loans. The State Gallery was founded in 1967 to allow a permanent display of the paintings in Ottobeuren. And to create a broader impression that better reflected the riches of the original gallery, works were exchanged and others added, with some being included that did not form part of the abbey's own collection. The last major changes were undertaken in 1989. More recently, all the pictures have been restored, displayed behind glass and provided with explanatory labels.

Even though today's permanent exhibition is small compared with the original monastic collection and occupies only a part of the historic picture gallery, the works on display still correspond to the composition of the Otto-

Johann Georg Bergmüller, The Patron Saints of Ottobeuren, 1739 (detail) | Inv. No. 7337

155

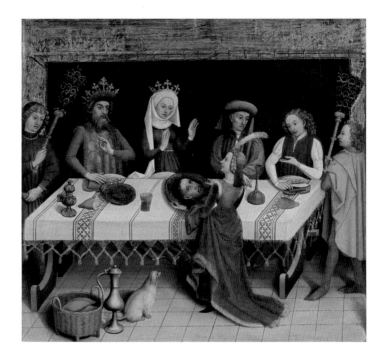

beuren collection as documented in 1803. Late-Gothic panels can be seen along with works of international Baroque. The image of the gallery is characterized by outstanding Early German paintings, for the most part by masters from Swabia and the Allgäu. Many of them are thought to have been among the original artworks in the abbey, its church or affiliate churches, which lost their original function during the Baroque period of rebuilding and structural alterations.

The gallery's showpiece is the 'Defence of the Inviolate Virginity of Mary', dating from about 1450. It was painted by the 'Master of the Ottobeuren Mary Panel' from Memmingen, who takes his name from this picture. The painting was presumably intended to stimulate the monks' theological reflections, given that it addressed a central dogma of Christian faith. Twenty-six images are arranged around the central field in the form of a lozenge that depicts the Virgin venerating the newborn Jesus. On a gold ground, finely executed scenes, taken from the Old Testament, history, classical mythology and natural history, serve to demonstrate the feasibility of the miracle of Jesus's virgin birth, as the inscriptions indicate. All the examples relate to an influential treatise by the Viennese Dominican Franz von Retz. Today's visitors can take pleas-

ure in miniature depictions of man and beast while at the same time gaining an insight into the late-medieval mindset.

A good example of the altarpiece fragments represented in the gallery is the painting 'Salome Presenting Herodias with the Head of St John the Baptist'. It comes from the wing of an altarpiece dedicated to the saint. (Another panel of the same altarpiece survives in the Staatsgalerie Stuttgart.) The recto displayed in the collection depicts the episode that follows on from the beheading incited by Salome: Herod's beautiful stepdaughter is portrayed bringing the Baptist's head to her mother, Herodias, who had long – but unsuccessfully – demanded his killing. The unknown painter represents the scene with uncommon vitality: the biblical protagonists are dressed like late-medieval nobility; the dining table is covered with a cloth whose fringes are decorated with elaborately knotted threads; a long-haired dog is seeking attention. The interplay of notions of nature and everyday life with late-medieval tradition can be observed frequently in Ulm painting around 1450.

While the first room has some works from the Baroque period, the smaller second room devotes itself entirely to this. Among the paintings there is the 'Patron Saints of Ottobeuren' by the director of the Augsburg Academy, Johann Georg Bergmüller, whose help Abbot Rupert called upon when decorating the abbey. The model of a sheet of theses, without a doubt commissioned by the abbey, is executed in grisaille. It shows the founders of the abbey, Count Silach and Countess Erminswintha, with a blank roll of parchment in their hands, which in the finished engraving contained a reproduction of the monastic buildings. Above them are the actual patron saints, Alexander and Theodore; and higher still, the apostles Peter and Paul, as well as the founder of the order, St Benedict.

Richly decorated ceilings vault the gallery rooms, and between elegant stucco ornaments are image fields with typical motifs of early modern painting: mythological and Old Testament episodes, hunting scenes and rural life. The ceilings thus lend the sequence of rooms an order of their own while documenting its former and current function. ELISABETH HIPP

Anonymous Master of Ulm (Workshop of Bartholomäus Zeitblom). SS Barbara and Catherine, c. 1500 (detail) | Inv. No. 4560

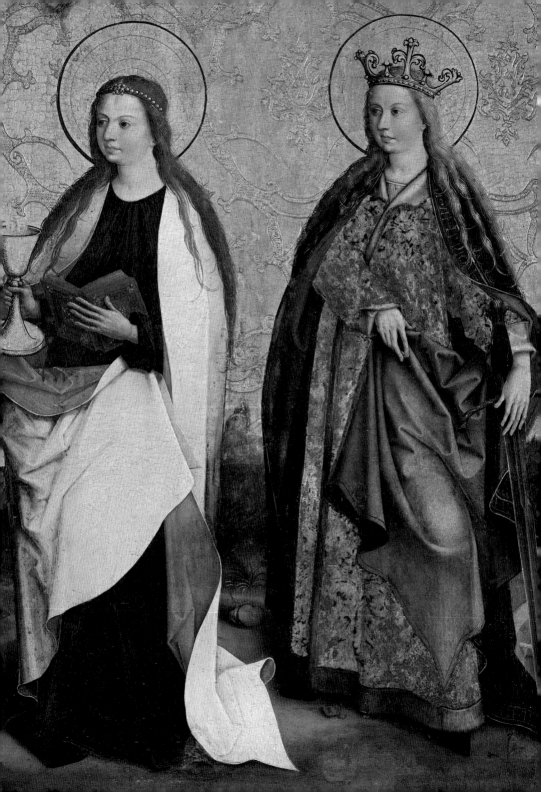

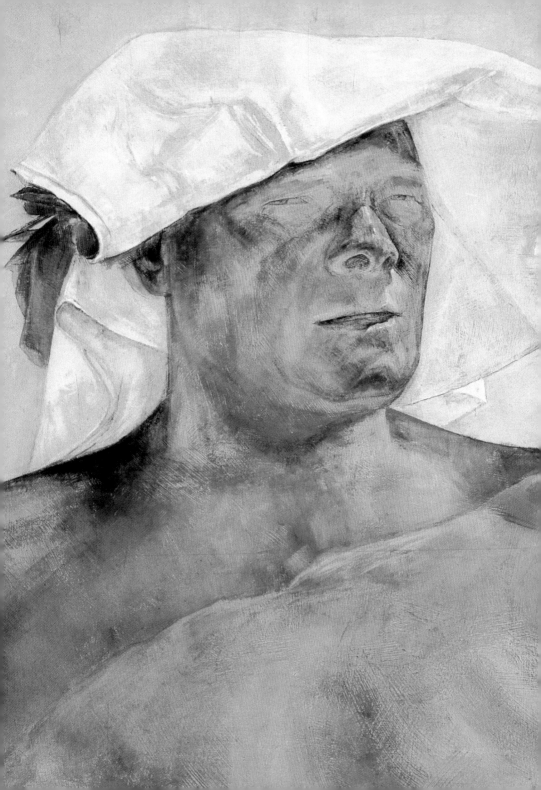

Tegernsee
Olaf Gulbransson Museum

Im Kurgarten 5, 83684 Tegernsee | T +49 (0)8022 3338 | Open daily except Mondays | Disability-friendly access to the extension building and ground floor of the Ruf building | www.pinakothek.de/olaf-gulbransson-museum

With a view of the monastery and the lake, shimmering turquoise or dark blue according to the season, the Olaf Gulbransson Museum is located in the grounds of Tegernsee spa. The elegant single-storey white building constructed by Sep Ruf houses the only single-theme museum among the branch galleries of the Bavarian State Painting Collections. It is devoted to the work of the Norwegian graphic artist with the unmistakable style.

The lines are as telling as they are fine and, by concentrating on the essential, portray, characterize and sometimes unmask his subjects. They stand for the high artistic quality of the œuvre of Olaf Gulbransson, who found his 'personal fjord' on Lake Tegernsee and there led a life both unconventional and close to nature.

Born in Oslo, Gulbransson, together with Thomas Theodor Heine, Karl Arnold and Eduard Thöny, was among the outstanding and legendary illustrators for the satirical Munich magazine *Simplicissimus*. He moved to the Bavarian capital in 1902 after being invited there by the magazine's publisher, Albert Langen. Until 1923 he and his second wife, the author Grete Jehly, led a wild social life in their home on Keferstrasse near the Englischer Garten park. High points included carnival parties attended by a scantily clad Gulbransson, which ended with his taking a dip in the Eisbach stream and being washed back to his 'Kefer nest'. After an interlude in Berlin, where he met Max Liebermann and began painting in oils, Gulbransson settled on Lake Tegernsee in 1929 with his third wife, Dagny Björnson. There he acquired a farmyard with a long tradition, the Schererhof, where he created much of the œuvre that graphic artists still seek to live up to. In the view of Luis Murschetz, for example, known for his caricatures in the *Süddeutsche Zeitung* and *Die Zeit*, Gulbransson is a 'Titan of graphic art'. For their part, the Norwegian cartoonists and illustrators Lars Fiske and Steffen Kverneland were inspired by Gulbransson's work to create a tribute to him in 2004 in the form of a comic biography, in which they immortalized their own pilgrimage from Drøbak in Norway to Lake Tegernsee.

In 1962, only four years after Gulbransson's death, an association was set up in Tegernsee to establish a museum in his memory. The patrons included

Olaf Gulbransson, Self-Portrait with Cloth, 1937 (detail) | Inv. No. OG 87

161

the then German president Theodor Heuss and Federal Chancellor Ludwig Erhard. The museum was built between 1964 and 1966 to designs by Sep Ruf, the architect of the chancellor's bungalow in Bonn, who was also based at Lake Tegernsee and a good friend of Dagny Björnson Gulbransson. The elegant white museum building hovers, slightly raised, above the green of the spa garden, and captivates visitors with its unique spatial experience, allowing views of the countryside without distracting from the art on display.

Sep Ruf and Dagny Björnson Gulbransson's circle of friends also included Erich Steingräber, who became director-general of the Bavarian State Painting Collections in 1969. On his initiative, the museum became a branch gallery of the collection. Since 1974, it has been run by the Olaf Gulbransson Society, which, closely associated with the museum, promotes the programme of exhibitions and lectures.

Thanks to an externally financed extension to the museum, it has been possible since 2008 to stage special exhibitions of works by related artists such as Eduard Thöny, Wilhelm Busch, Käthe Kollwitz, Bruno Paul and Herrmann Hesse. These successfully complement the permanent exhibition, in which the museum presents caricatures by Olaf Gulbransson – such as the series of 'Famous Contemporaries' with depictions of Eleonora Duse, Maxim Gorki, Henrik Ibsen, Max Klinger and Richard Strauss. Also on display are Gulbransson's commissioned works for *Simplicissimus*, whose political statements are still relevant today, and not least of all his highly praised book illustrations that accompany the *Lausbubengeschichten* of Ludwig Thoma, the *Fairy Tales* of Hans Christian Andersen and Gulbransson's own autobiography, *Es war einmal*. His principal works undoubtedly include the self-portraits that show him almost naked with Iroquois-like headdress and the delightful portraits, tender and monochrome, of his wife Dagny and the grandchildren. Gulbransson created them in close harmony with nature from the mid-1930s onwards in delicate oil paintings, in which references are made to the Alpine foothills in whose midst he lived. ANDREA BAMBI

Olaf Gulbransson, The Distinguished Dog, 1908 | Inv. No. OG 439

Der vornehme Hund

„Ich habe zwanzig Ahnen und muß mit einem Weibsbild gehen, das zwanzig Nachkommen hat!"

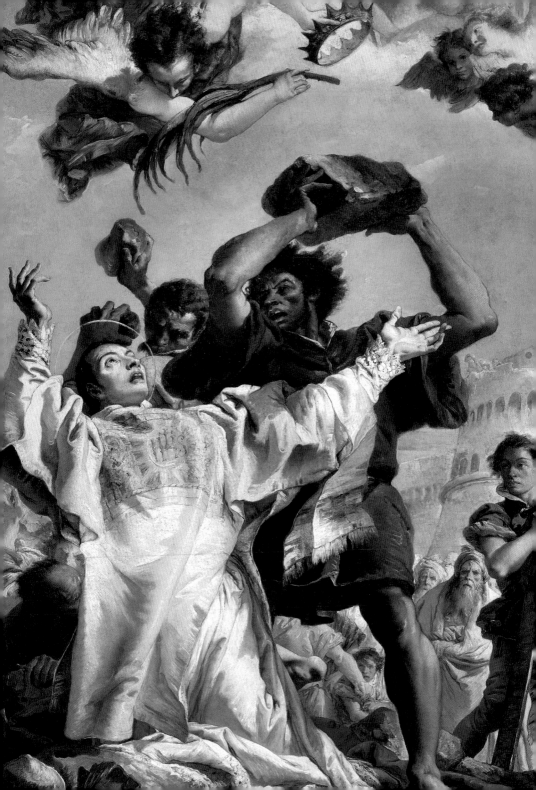

Würzburg
State Gallery in the Würzburg Residenz

Residenzplatz 2, 97070 Würzburg | T +49 (0)931 355170 | Disabled-friendly access |
www.pinakothek.de/staatsgalerie-wuerzburg | Due to reopen in autumn/winter 2016

The Residenz, or palace, of the prince-bishops of Würzburg owes its fame to Balthasar Neumann's magnificent architecture and, in particular, to the highlight of its rich decoration – Giovanni Battista Tiepolo's paintings in the Kaisersaal and stairwell. In the breathtaking ceiling fresco that Tiepolo painted in the vault of the broad stairwell in 1752/53, the visitor will encounter one of the most important works of eighteenth-century Venetian art. Accordingly, the gallery in the north wing of the palace is devoted to the great age of Venetian painting.

At the centre of the presentation, in a large oval room originally furnished as a theatre, is 'The Stoning of St Stephen', which was acquired in 2006. Giovanni Domenico Tiepolo, the son and assistant of Giovanni Battista, was commissioned to create this monumental altarpiece by the Benedictine Abbey of Münsterschwarzach in 1754. Like the 'Adoration of the Magi' in the Alte Pinakothek, which Giovanni Battista had painted the previous year as one of his 'winter pictures' when weather conditions interrupted his fresco work, his son's painting was intended for one of the side-altars of the abbey church (which, however, was demolished after 1810). Also on display in the oval hall are festively light-hearted paintings by Paolo Veronese, which enable the beholder to understand how deeply the art of Tiepolo, fêted by his contemporaries as the new Veronese, was rooted in the Venetian High Renaissance. With his light-flooded works in forcefully cool colours, Veronese, along with Titian and Tintoretto, shaped the Golden Age of Venetian painting in the sixteenth century. The four-part picture cycle from his workshop shows beauties clothed in luxurious fabrics as embodiments of the Seven Virtues. A second series from the succeeding generation, also on display in Würzburg, bears prominent witness to the close political and economic links between Venice and the Ottoman Empire. Contemporary prints served as the basis for 14 portraits of the Turkish sultans up to and including the then ruler. They probably provided the model for a similar series which the Doge sent to the sultan's court in 1579.

Visitors touring the palace leave the reconstructed imperial state rooms on the north side and enter a generously proportioned enfilade comprising six rooms and the above-mentioned hall. These rooms, with windows overlooking

165

the Rennweg to the north – and already the location for a second, smaller gallery in the eighteenth century – were sparsely decorated when the palace was restored. Since 1974, they have housed the State Gallery and provide a reticent backdrop against which the paintings can unfold their appeal to full effect. The pictures in the gallery, which has always focused on Venetian painting, were last rehung in 2002 and are currently being rearranged with the addition of further important works in order to reinforce its central themes. The presentation is greatly enhanced by new silk wall hangings. Thanks to extensive restoration measures, it has been possible to recreate the pristine radiance and wealth of colours of selected works.

The second section of the gallery, which has a total of 50 works, is arranged in chronological order. Here, the visitor may well be surprised by the powerful chiaroscuro and classical figure-ideal displayed in the mythological depictions by Antonio Bellucci, for at first sight they seem alien to the Venetian spirit. Like most of his fellow seventeenth-century artists active in Venice, Bellucci looked to Rome for inspiration and found it in the epoch-making innovations of Caravaggio and the Bologna-born Carraccis. Bellucci's pair of paintings showing Danae on the raft and Cupid with Psyche was commissioned by the Elector Palatine Johann Wilhelm. Bellucci's invitation to his court in Düsseldorf

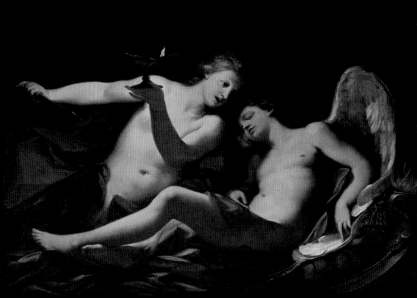

points ahead to the Europe-wide dissemination and dominance of Venetian painting in the eighteenth century. Now the successful masters no longer worked primarily for the churches and palaces in their home city, which had meanwhile lost all power and influence, but rather for the European nobility and in the service of the leading courts. Thus Giovanni Battista Pittoni, represented here with two history paintings in lively Rococo elegance, was appreciated far and wide.

Two of Tiepolo's most beautiful easel paintings form the culmination and crowning glory of the gallery. Painted by Giovanni Battista in 1753, they depict two scenes from Torquato Tasso's epic *Jerusalem Delivered*. On the one side, the enchantress Armida is tenderly united in the garden of love with her handsome knight Rinaldo, whom she has under her spell, but without whom Jerusalem cannot be taken; on the other side, the separation of the lovers in the wilderness into which the garden is transformed after Rinaldo's retinue succeeds in breaking the spell. The portrayals of this fairy-tale world, composed with great lightness of touch, but at the same time with detailed calculation, exemplify the virtuosity and intelligence of the whole of Tiepolo's œuvre.

ANDREAS SCHUMACHER

Permanent Loans from the Bavarian State Painting Collections

Artworks from the Bavarian State Painting Collections are to be found throughout Bavaria, not just in the collection's branch galleries, but also elsewhere in the state, as works on permanent loan. There are more than 4,000 such listed items in museums, palaces, churches, monasteries and official buildings, such as those in the Bavarian State Chancellery, the Bavarian Parliament, various ministries, courtrooms, town halls and university institutes. The locations amount to some 400 in total throughout Bavaria and beyond the state, as there are paintings from the Bavarian State Painting Collections in the German embassies in Brussels, London, Madrid, Paris, Prague and the Holy See (Vatican), as well as in various other institutions at home and abroad.

In most cases, the works in the museums and palaces in Bavaria (see the list below and the overview map on the reverse of the front flap) are accessible to the public. With 221 German paintings dating from the fifteenth to the eighteenth century, the Germanisches Nationalmuseum in Nuremberg houses a particularly large number of valuable loans. They include important works by Lucas Cranach the Elder, Albrecht Altdorfer and, not least, Albrecht Dürer, an example being the well-known portrait of his teacher Michael Wolgemut. Larger groups come from the Boisserée Collection and that of Prince von Oettingen-Wallerstein, which King Ludwig I purchased in 1827 and 1828 respectively, and now form part of the collection of the Wittelsbacher Ausgleichsfonds. Paintings from the Bavarian State Painting Collections are likewise to be found in the Historisches Museum of the city of Regensburg, with numerous works by Early German and Baroque artists, including a portrait of Martin Luther and one of Philipp Melanchthon by Lucas Cranach the Elder. Cranach's Magdalene Altar, which Cardinal Albrecht of Brandenburg transferred from Halle to Aschaffenburg, is a central exhibit at the Stiftsmuseum in Aschaffenburg. The wings and predella are on loan from the Bavarian State Painting Collections.

Portraits of princes and battle scenes are on display at the Bavarian Army Museum in Ingolstadt. The Bavarian State Painting Collections have also enhanced the collection of the Dachau Painting Gallery by lending it some of the works by painters active there in the second half of the nineteenth century, for instance Arthur Langhammer and Fritz von Uhde. Among them are many works acquired directly from the artists or their estates. On permanent loan to

the Murnau Castle Museum are a number of landscapes of the time, while the exhibition at the museum in the former Augustinian priory at Herrenchiemsee includes nineteenth- and twentieth-century paintings portraying the lake.

Visitors to the numerous palaces, most of which are state-owned, will often come across permanent loans from the Bavarian State Painting Collections in the magnificent rooms. In several cases these locations are, in fact, where the artworks originated. In Ansbach, for example, the majority of loans, primarily princely portraits on display outside the confines of the gallery itself, originally formed part of the margravial collection. The eighteenth-century 'Green Gallery' in the Munich Residenz, reconstructed by the Bavarian Palace Department some years ago and in which 17 loans are on show, recalls the long history of the Wittelsbach dynasty as collector in Munich. In this historic place, visitors have the opportunity to discover one of the precursor galleries of the Alte Pinakothek.

Many recipients of loans have also made loans. Thus numerous branch galleries of the Bavarian State Painting Collections are indebted to the Bayerisches Nationalmuseum for important loans (among them the two attractive panels of the Annunciation in Ottobeuren) while, in turn, the Nationalmuseum displays loans from the Bavarian State Painting Collections: for example in the Cabinet of Curiosities in Burg Trausnitz in Landshut (fig. p. 2) and the Fränkische Galerie in Kronach. And where would the State Gallery in Bamberg be without the 41 works provided by the city's museums, including the spectacular 'Flood' by Hans Baldung Grien (fig. p. 118)? ELISABETH HIPP

Selected locations of works on permanent loan

The Bavarian State Painting Collections cannot guarantee that the loans are actually on display in all the places listed. For various reasons, such as construction works or new concepts, it may be that particular artworks are not on view at any given time.

Ansbach, Residenz
Aschach, Museum Schloss Aschach
Aschaffenburg, Schloss Johannisburg
und Schlossmuseum
Aschaffenburg, Schloss Schönbusch
Aschaffenburg, Stiftsmuseum
Augsburg, Städtische Kunstsammlungen
Bad Aibling, Heimatmuseum
Bamberg, Historisches Museum
Bamberg, Neue Residenz
Bayreuth, Altes Schloss Eremitage
Bayreuth, Gartenkunst-Museum Schloss
Fantaisie
Bayreuth, Historisches Museum
Bayreuth, Neues Schloss
Bayreuth, Morgenländischer Bau im
Felsengarten Sanspareil
Berchtesgaden, Königliches Schloss
Burghausen, Burg
Burghausen, Stadtmuseum
Coburg, Veste Coburg
Dachau, Gemäldegalerie Dachau
Dingolfing, Museum Dingolfing
Eichstätt, Domschatz- und Diözesan-
museum
Ellingen, Residenz
Freising, Diözesanmuseum
Herrenchiemsee, Augustiner-
Chorherrenstift
Höchstädt, Schloss
Hof, Museum Bayerisches Vogtland
Ingolstadt, Bayerisches Armeemuseum
Kempten, Residenz
Kochel, Franz Marc Museum

Kronach, Fränkische Galerie
Kulmbach, Plassenburg
Landshut, Burg Trausnitz
Landshut, Stadtresidenz
Lohr am Main, Spessartmuseum
Munich, Bayerisches Nationalmuseum
Munich, Deutsches Jagd- und Fischerei-
museum
Munich, Residenz
Munich, Schloss Nymphenburg
Murnau, Schlossmuseum
Neuburg an der Donau, Schlossmuseum
Nördlingen, Stadtmuseum
Nuremberg, Albrecht-Dürer-Haus
Nuremberg, Burg
Nuremberg, Germanisches National-
museum
Oberschleissheim, Schloss Lustheim
Oberschwappach, Museum Schloss
Oberschwappach
Passau, Oberhausmuseum
Polling, Museum Polling
Regensburg, Historisches Museum
Regensburg, Kunstforum Ostdeutsche
Galerie
Regensburg, Reichstagsmuseum
Rothenburg ob der Tauber, Reichsstadt-
museum
Veitshöchheim, Schloss
Würzburg, Mainfränkisches Museum
Würzburg, Martin von Wagner Museum
Würzburg, Museum am Dom
Würzburg, Residenz

Catalogue of Works

Albrecht Altdorfer
Regensburg, c.1482/85 – Regensburg, 1538
The Battle of Issus (Alexander's Battle), 1529
Lime wood, 158.4 × 120.3 cm
Inv. No. 688
▶ Fig. p. 16

Anonymous Master (Workshop of Lucas Cranach the Elder)
The Mass of St Gregory with Cardinal Albrecht of Brandenburg, 1520/25
Wood, 150.2 × 110 cm
Inv. No. 6270
▶ Fig. p. 104

Anonymous Master of Ulm
Active c.1460/65
Altar of St Mang's Abbey, Füssen:
The Betrothal of the Virgin, c.1460/65
Wood, 87 × 107 cm
Inv. No. WAF 1096
▶ Fig. p. 138

Anonymous Master of Ulm (Workshop of Bartholomäus Zeitblom)
Active c.1500
SS Barbara and Catherine, c.1500
Fir wood, 87.4 × 61.5 cm
Inv. No. 4560
▶ Fig. p. 159

Giuseppe Arcimboldo
Milan, 1526 – Milan, 1593
Summer, c.1555/60
Canvas, 68.1 × 56.5 cm
Inv. No. 2038
▶ Fig. p. 2

Ludolf Backhuysen
Emden, 1630 – Amsterdam, 1708
The Roads of Plymouth (Marine), 1680
Canvas, 88.5 × 135 cm
Inv. No. 2007
▶ Fig. pp. 102/03

Hans Baldung, called Grien
Schwäbisch Gmünd, 1484/85 – Strasbourg, 1545
The Flood, 1516
Lime wood, 81.9 × 65.2 cm
Inv. No. L 1549, Loan from the City of Bamberg
▶ Fig. p. 118

Calvary, c.1533/36
Lime wood, 96 × 68.5 cm
Inv. No. 6277
▶ Fig. p. 107

Bavarian Master
Flight into Egypt, c.1500
Softwood, 79.1 × 69 cm
Inv. No. 2618
▶ Fig. p. 135

Bavarian (?) Master
Portrait of Hans Hofer, c.1485
Softwood, 45.1 × 37.2 cm
Inv. No. 12422
▶ Fig. p. 132

Bavarian Master (Master of the Attel Altar)
Attel Altar: Feast of Herod with the Beheading of St John the Baptist, c.1480/90
Softwood, 122.7 × 131.2 cm
Inv. No. 1405
▶ Fig. p. 133

Max Beckmann
Leipzig, 1884 – New York, 1950
Large Still Life with Telescope, 1927
Oil on canvas, 140.7 × 200 cm
Inv. No. 13454
▶ Fig. p. 46

Johann Georg Bergmüller
Türkheim, 1688 – Türkheim, 1762
The Patron Saints of Ottobeuren, 1739
Canvas, 109 × 74 cm
Inv. No. 7337
▶ Fig. p. 154

Antonio Bellucci
Pieve di Soligo, 1654 – Pieve di Soligo, 1726/27
Cupid and Psyche, n.d.
Canvas, 111 × 170 cm
Inv. No. 915
▶ Fig. p. 167

Joseph Beuys
Krefeld, 1921 – Düsseldorf, 1986
The End of the 20th Century, 1983
Basalt, clay, felt, 44 stones, each 48 × 150 × 40 cm
Inv. No. GV 81
▶ Fig. pp. 48/49

Abraham Bloemaert
Gorinchem, 1566 – Utrecht, 1651
The Preaching of St John the Baptist, c.1620
Canvas, 78.5 × 127.5 cm
78.5 × 136 cm (with attachments)
Inv. No. 2045
▶ Fig. p. 106

Arnold Böcklin
Basle, 1827 – S. Domenico di Fiesole, 1901
Villa at the Seaside II, 1865
Oil and tempera on canvas, 123.4 × 173.2 cm
Inv. No. 11536
▶ Fig. p. 41

Jan Both
Utrecht, c.1615 – Utrecht, 1652
Roman Ruins with Card Players, c.1640
Canvas, 66.3 × 83.6 cm
Inv. No. 1016
▶ Fig. p. 100

François Boucher
Paris, 1703 – Paris, 1770
Portrait of Madame de Pompadour, 1756
Canvas, 201 × 157 cm,
Inv. No. HUW 18, Loan from the Collection
of HypoVereinsbank, Member of UniCredit
▶ Fig. p. 23

Kerstin Brätsch
Hamburg, 1979
Unstable Talismanic Rendering 19 (with gratitude
to master marbler Dirk Lange), 2014
Ink and solvent on paper, 278.1 × 182.9 cm
Inv. No. UAB 908
▶ Fig. p. 65

Jan Brueghel the Elder
Brussels, 1568 – Antwerp, 1625
and **Hendrik van Balen**
Antwerp, 1575 – Antwerp, 1632
Spring, 1616
Copper, 57.1 × 84.9 cm
Inv. No. 13709
▶ Fig. pp. 146/47

Hans Burgkmair the Elder
Augsburg, 1473 – Augsburg, 1531
All Saints Altar: Mary and Christ Enthroned, 1507
Softwood, 169.8 × 129.8 cm
Inv. No. 5325
▶ Fig. p. 110

Giacomo Caneva
Padua, 1813 – Rome, 1865
Temple of Vesta in Tivoli, c.1850
Salted paper print from paper negative
Picture size: 26.5 × 34.0 cm,
Viewing size: 20 × 25.1 cm
▶ Fig. p. 28

Lucas Cranach the Elder
Kronach, 1472 – Weimar, 1553
Samson and Delilah, 1529
Lime wood, 117.2 × 81.9 cm
Inv. No. L 1696, Loan from the Collections
and Museums of Augsburg
▶ Fig. p. 115

Jacques-Louis David
Paris, 1748 – Brussels, 1825
Anne-Marie-Louise Thélusson,
Comtesse de Sorcy, 1790
Oil on canvas, 129 × 97 cm
Inv. No. HUW 21, Loan from the Collection
of HypoVereinsbank, Member of UniCredit
▶ Fig. p. 27

Albrecht Dürer
Nuremberg, 1471 – Nuremberg, 1528
Self-Portrait, 1500
Lime wood, 67.1 × 48.9 cm
Inv. No. 537
▶ Fig. p. 12

Portrait of Jakob Fugger 'the Rich', c.1520
Canvas, 69.4 × 53 cm
Inv. No. 717
▶ Fig. p. 114

Portrait of the Painter Michael Wolgemut from
Nuremberg, 1516
Lime wood, 29.8 × 28.1 cm
Inv. No. 700, Permanent loan from the Bavarian
State Painting Collections to the Germanisches
Nationalmuseum, Nuremberg
▶ Fig. p. 170

Anthony van Dyck
Antwerp, 1599 – London, 1641
The Healing of the Paralytic, n.d.
Canvas, 90 × 119 cm
Inv. No. 559
▶ Fig. p. 145

Anselm Feuerbach
Speyer, 1829 – Venice, 1880
Paolo and Francesca, 1864
Oil on canvas, 137 × 99.5 cm
Inv. No. 11521
▶ Fig. p. 38

Dan Flavin
Jamaica (New York), 1933 – Riverhead (New York),
1996
'monument' (for V. Tatlin), 1969
7 luminescent tubes, lime-white fluorescence,
305 × 71 × 11 cm
Inv. No. GST 6, Loan from Stiftung Galerie-Verein
zur Förderung staatl. bayerischer Museen
▶ Fig. p. 54

Caspar David Friedrich
Greifswald, 1774 – Dresden, 1840
Riesengebirge Landscape with Rising Fog, c.1819/20
Oil on canvas, 54.9 × 70.4 cm
Inv. No. 8858
▶ Fig. p. 30

Jan Fyt
Antwerp, 1611 – Antwerp, 1661
Still Life with Fruit and Two Monkeys, n.d.
Canvas, 77.5 × 121 cm
Inv. No. 1719
▶ Fig. p. 101

Luca Giordano
Naples, 1634 – Naples, 1705
The Death of Seneca, n.d.
Canvas, 259 × 241 cm
Inv. No. 516
▶ Fig. p. 150

Vincent van Gogh
Zundert, 1853 – Auvers-sur-Oise, 1890
Sunflowers (Tournesols), 1888
Oil on canvas, 92 × 73 cm
Inv. No. 8672
▶ Fig. p. 24

Olaf Gulbransson
Oslo, 1873 – Tegernsee, 1958
The Distinguished Dog, 1908
Plume, brush, ink and watercolour on cardboard,
38 × 28.9 cm
Inv. No. OG 439
▶ Fig. p. 163

Self-Portrait with Cloth, 1937
Oil on wood, 49.2 × 53 cm
Inv. No. OG 87
▶ Fig. p. 160

Gerard Hoet
Zaltbommel, 1648 – The Hague, 1733
The Triumphal Procession of Venus, n.d.
Walnut wood, 60.4 × 79.4 cm
Inv. No. 6617
▶ Fig. p. 127

Hans Holbein the Elder
Augsburg, 1460/65 – Basle, 1524/34
Painting Series from Santa Maria Maggiore,
Central Panel: The Coronation of the Virgin, 1499
Fir wood, 234.6 × 113.8 cm
Inv. No. 5335
▶ Fig. p. 113

Donald Judd
Excelsior Springs, 1928 – New York, 1994
Untitled, 16 unit wall-boxes, 1978
American Douglas fir plywood,
each 50 × 100 × 50 cm
Inv. No. B 931 1/16 – 16/16
▶ Fig. pp. 52/53

Alex Katz
Brooklyn, 1927
Paul Taylor Dance Company, 1963/64
Oil on canvas, 213 × 244 cm
Inv. No. UAB 207
▶ Fig. p. 58

Ernst Ludwig Kirchner
Aschaffenburg, 1880 – Davos Frauenkirch, 1938
Self-Portait as an Invalid, 1918/30 (?)
Oil on canvas on plywood, 59 × 69.3 cm
Inv. No. 15580
▶ Fig. p. 42

Paul Klee
Münchenbuchsee, 1879 – Locarno-Muralto, 1940
Light and Other Things, 1931
Oil on canvas, 95.9 × 98 cm
Inv. No. 14070
▶ Fig. p. 45

Jannis Kounellis
Piraeus, 1936
Untitled (Rimbaud), 1980
Paint bucket, parrot, brush and books, 37 × 23 × 24 cm
Inv. No. UAB 260
▶ Fig. p. 59

Gerard de Lairesse
Liège, 1640 – Amsterdam, 1711
The Triumphal Procession of Alexander the Great:
March of the Prisoners (Series 7/12), n.d.
Paper, 55.3 × 96.7 cm
Inv. No. 4955
▶ Fig. p. 126

Franz von Lenbach
Schrobenhausen, 1836 – Munich, 1904
Shepherd Boy, 1860
Oil on canvas, 107.7 × 154.4 cm
Inv. No. 11450
▶ Fig. p. 39

Max Liebermann
Berlin, 1847 – Berlin, 1935
Woman with Goats in the Dunes, 1890
Oil on canvas, 127 × 172.5 cm
Inv. No. 7815
▶ Fig. p. 35

Jacob van Loo
Sluis, 1614 – Paris, 1670
Allegory of Fortune, 1655
Canvas, 114 × 94.5 cm
Inv. No. 2361
▶ Fig. p. 120

Édouard Manet
Paris, 1832 – Paris, 1883
The Luncheon (Le déjeuner), 1868
Oil on canvas, 118.3 × 154 cm
Inv. No. 8638
▶ Fig. pp. 32/33

Walter De Maria
Albany, 1935 – Los Angeles, 2013
Large Red Sphere, 2010
Granite, diameter 260 cm
Inv. No. UAB 666
▶ Fig. p. 66

Master of the Heisterbach Altar
Active in Cologne, c. 1430/40
Crucifixion Altar, central panel: The Crucifixion
of Christ, Mary and the Apostles James the Elder,
St Peter, St John the Baptist, Andrew, Thomas
and Bartholomew, 1440s
Oak wood, 132.8 × 164.4 cm
Inv. No. WAF 503
▶ Fig. p. 123

Master of the Ottobeuren Mary Panel
Active c. 1450
Defence of the Inviolate Virginity of Mary, c. 1450
Spruce wood, 107.3 × 78.9 cm
Inv. No. 1472
▶ Fig. p. 156

Claude Monet
Paris, 1840 – Giverny, 1926
Water Lilies (Nymphéas), c. 1915
Oil on canvas, 151.4 × 201 cm
Inv. No. 14562
▶ Fig. p. 6

Bruce Nauman
Fort Wayne, 1941
Mean Clown Welcome, 1985
Fluorescent light tubes, lacquered metal,
183 × 208 × 29 cm
Inv. No. UAB 299
▶ Fig. p. 56

Cady Noland
Washington, D.C., 1956
Deep Social Space, 1989
Mixed media, 130 × 270 × 700 cm
Inv. No. UAB 323
▶ Fig. p. 64

Friedrich Overbeck
Lübeck, 1789 – Rome, 1869
Italia and Germania, 1828
Oil on canvas, 94.5 × 104.7 cm
Inv. No. WAF 755
▶ Fig. p. 29

Pablo Picasso
Malaga, 1881 – Mougins, 1973
Woman Seated: Dora Maar (Femme assise
au fauteuil: Dora Maar), 1941
Oil on canvas, 99.8 × 80.5 cm
Inv. No. 14240
▶ Fig. p. 47

Sigmar Polke
Oleśnica, 1941 – Cologne, 2010
The Three Lies of Painting, 1994
Synthetic resin paint, lacquer on synthetic fabric,
printed fabric, 300 × 400 cm
Inv. No. UAB 350
▶ Fig. p. 63

Nicolas Poussin
Les Andelys, 1594 – Rome, 1665
Midas and Bacchus, c. 1624
Canvas, 98.5 × 153 cm
Inv. No. 528
▶ Fig. p. 17

The Adoration of the Shepherds, c. 1650/57
Canvas, 97.2 × 131.2 cm
Inv. No. 617
▶ Fig. p. 151

Jean-Baptiste Le Prince
Metz, 1734 – Saint-Denis-du-Port, 1781
The Secret Lover, 1774
Canvas, 73 × 91 cm
Inv. No. 39
▶ Fig. p. 98

Raphael (Raffaello Santi)
Urbino, 1483 – Rome, 1520
Holy Family from the House of Canigiani, c. 1505/06
Lime wood, 131.7 × 107 cm
Inv. No. 476
▶ Fig. p. 15

Neo Rauch
Leipzig, 1960
Election, 1998
Oil on canvas, 300 × 200 cm
Inv. No. GV 140
▶ Fig. p. 51

Rembrandt (Rembrandt Harmensz van Rijn)
Leiden, 1606 – Amsterdam, 1669
Passion of Christ: The Deposition, 1633
Wood, 89.4 × 65.2 cm
Inv. No. 395
▶ Fig. p. 20

Rembrandt (Workshop)
St John the Evangelist, 1661
Canvas, 98.5 × 77.6 cm
Inv. No. 2174
▶ Fig. p. 109

Gerhard Richter
Dresden, 1932
Coffin Bearers, 1962
Oil on canvas, 135 × 180 cm
Inv. No. GV 56
▶ Fig. p. 50

Auguste Rodin
Paris, 1840 – Meudon, 1917
Helene von Nostiz, 1907
Marble, 54.3 × 50.5 × 28 cm
Inv. No. FV 11
▶ Fig. p. 26

Peter Paul Rubens
Siegen, 1577 – Antwerp, 1640
Rubens and Isabella Brant in the Honeysuckle
Bower, c. 1609/10
Canvas, 179 × 136.7 cm
Inv. No. 334
▶ Fig. p. 19

The Adoration of the Shepherds, 1619
Canvas, 476 × 276 cm
Inv. No. 303
▶ Fig. p. 144

The Reconciliation of Esau and Jacob, n.d.
Canvas, 330 × 283 cm
Inv. No. 1302
▶ Fig. p. 148

Rachel Ruysch
Amsterdam, 1664 – Amsterdam, 1750
Bouquet of Flowers, 1708
Canvas, 92.3 × 70.2 cm
Inv. No. 430
▶ Fig. p. 124

August Sander
Herdorf, 1876 – Cologne, 1964
Painter (Heinrich Hoerle), 1928/36
Gelatin silver print on baryta paper, 59.3 × 47.4 cm
Acquired in 2014 from the collection of Lothar
Schirmer, Munich
Inv. No. 16344
▶ Fig. p. 44

Joachim von Sandrart
Frankfurt (Main), 1605/06 – Nuremberg, 1688
From a Series on the Months: Allegory of
November, 1643
Canvas, 149 × 123.5 cm
Inv. No. 366
▶ Fig. p. 153

School of Ulm
Salome Presenting Herodias with the Head
of St John the Baptist, c. 1450
Fir and spruce wood, 84.5 × 88.5 cm
Inv. No. 1462
▶ Fig. p. 157

Wilhelm Schubert van Ehrenberg
(with Jacob Jordaens, Gonzales Coques, et al.)
Ehrenberg (?), 1630/37 – Antwerp, 1676
View of a Picture Gallery, 1666
Canvas, 142.5 × 237 cm
Inv. No. 896
▶ Fig. p. 142

Moritz von Schwind
Vienna, 1804 – Munich / Niederpöcking, 1871
The Morning Hour, c. 1860
Oil on canvas, 34.8 × 41.9 cm
Inv. No. 11559
▶ Fig. p. 36

Bernhard Strigel (copy after)
Emperor Maximilian I, 17th century
Softwood, 83.3 × 49.7 cm
Inv. No. 1156
▶ Fig. p. 136

Giovanni Battista Tiepolo
Venice, 1696 – Madrid, 1770
The Adoration of the Magi, 1753
Canvas, 408 × 210.5 cm
Inv. No. 1159
▶ Fig. p. 21

Rinaldo's Separation from Armida, n.d.
Canvas, 105 × 160 cm
Inv. No. L 165, Loan from the Bavarian Palace
Department
▶ Fig. pp. 168/69

Giovanni Domenico Tiepolo
Venice, 1727 – Venice, 1804
The Stoning of St Stephen, 1754
390.5 × 204.5 cm
Inv. No. 15687
▶ Fig. p. 164

Titian (Tiziano Vecellio)
Pieve di Cadore, c. 1485/90 – Venice, 1576
Christ Crowned with Thorns, c. 1570
Canvas, 280 × 182 cm
Inv. No. 2272
▶ Fig. p. 18

Joseph Mallord William Turner
London, 1775 – Chelsea, 1851
Ostend, 1844
Oil on canvas, 91.6 × 122 cm
Inv. No. 14435
▶ Fig. p. 31

Cy Twombly
Lexington (Virginia), 1928 – Rome, 2011
Lepanto I–XII, 2001
Acrylic, wax crayon and graphite on canvas,
210. 8 × 287.7 cm; 217.2 × 312.4 cm; 215.9 × 334 cm;
214 × 293.4 cm; 215.9 × 303.5 cm; 211.5 × 304.2 cm;
216.5 × 340.4 cm; 215.9 × 334 cm; 215.3 × 335.3 cm;
215.9 × 334 cm; 216.2 × 335.9 cm; 214.6 × 293.4 cm
Inv. No. 469–480
▶ Fig. pp. 60/61

Upper Swabian Master
The War, c. 1510
Softwood, 92.7 × 95.4 cm
Inv. No. WAF 740
▶ Fig. p. 141

Otto van Veen
Leiden, c.1556 – Brussels, 1629
Triumph of the Catholic Church, n.d.
Wood, 75.3 × 106.3 cm
Inv. No. 807
▶ Fig. p. 121

Paolo Veronese (Paolo Caliari)
Verona, 1528 – Venice, 1588
Sultan Orchard II, n.d.
Canvas, 69 × 54 cm
Inv. No. 2236
▶ Fig. p. 166

Joseph Vivien
Lyons, 1657 – Sonn, 1734
Allegory on Elector Max Emanuel and His Family
Reunited, 1733
Canvas, 530 × 644 cm
Inv. No. 2477
▶ Fig. p. 152

Jeff Wall
Vancouver, 1946
An Eviction, 1988/2004
Cibachrome diapositive in a light-box, 229 × 414 cm
Inv. No. 15319
▶ Fig. p. 55

Andy Warhol
Pittsburgh, 1928 – New York, 1987
Self-Portrait, 1986
Synthetic resin paint and silk-screen ink on canvas,
203.2 × 193.5 cm
Inv. No. UAB 598
▶ Fig. p. 62

Jan Weenix
Amsterdam, 1640/42 – Amsterdam, 1719
Hunting Still Life with Peacock, 1708
Canvas, 151.8 × 179 cm
Inv. No. 541
▶ Fig. pp. 128/29

Hans Werl
Munich, c.1570 – Munich, 1608
Ludwig IV of Bavaria Defeating Friedrich III
of Habsburg in the Battle of Mühldorf, 1322
(The Battle of Ampfing), 1601–05
Canvas, 225 × 1080 cm
Inv. No. 3750
▶ Fig. p. 130

Rogier van der Weyden
Tournai, 1399/1400– Brussels, 1464
Altar of the Magi (Columba Altar),
left wing: The Annunciation, c.1455
Oak wood, 139.4 × 72.9 cm
Inv. No. WAF 1190
▶ Fig. p. 14

Bartholomäus Zeitblom
Nördlingen, 1455/60 – Ulm, 1518/22
Ursprung Retable, separated panel from the
right wing: St Anthony the Abbot, c.1482/85
Softwood, 70.7 × 48.1 cm
Inv. No. WAF 1209
▶ Fig. p. 139

Bayerische Staatsgemäldesammlungen
Idea and concept: Bernhard Maaz
Project management: Christine Kramer
and Nadine Engel
Research associate: Nadine Engel
Editors/copy-editors: Nadine Engel
and Christine Kramer
Content editing for the English edition:
Carol Carl, Munich
Picture editor/picture rights: Nadine Engel
Conservation consultants: Eva Ortner,
Jan Schmidt et al.
Marketing and press: Tine Nehler and Antje Lange

Project coordination, Hirmer Publishers:
Jutta Allekotte
Translation from the German: Michael Scuffil,
Leverkusen
Copy-editing: Danko Szabó, Munich
Graphic design: Peter Grassinger
Prepress and repro: Reproline Genceller, Munich
Printing: F&W Mediencenter, Kienberg

Bibliographic information published by the
Deutsche Nationalbibliothek: The Deutsche
Nationalbibliothek lists this publication in
the Deutsche Nationalbibliografie; detailed
bibliographic data is available on the Internet
at www.dnb.de.

© 2015 Bayerische Staatsgemäldesammlungen,
Munich, Hirmer Verlag GmbH, Munich, and the
authors
ISBN 978-3-7774-2544-3 (English edition)
ISBN 978-3-7774-2534-4 (German edition)

Printed in Germany

www.hirmerpublishers.com

Cover illustration
Willem Schubert van Ehrenberg et al., View of
a Picture Gallery, 1666 (detail), Neuburg an der
Donau, State Gallery in Neuburg Palace

Frontispice
Giuseppe Arcimboldo, Summer, c. 1555/60 (detail),
Landshut, Burg Trausnitz, Kunst- und Wunder-
kammer | On loan from the Bavarian State Picture
Collections to the Bayerisches Nationalmuseum